new technologies in
GLASS

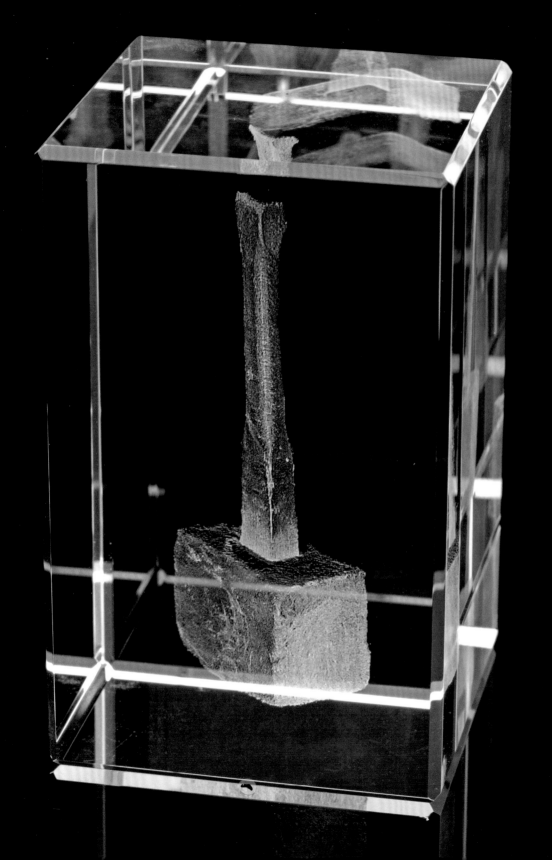

new technologies in
GLASS

Vanessa Cutler

A & C BLACK • London

This book is dedicated to my father,
for making me an inquisitive engineer.

First published in Great Britain 2012 by
A & C Black Publishers
an imprint of Bloomsbury Publishing Plc
50 Bedford Square
London WC1B 3DP
www.acblack.com

ISBN 978-1-4081-3954-7

A CIP catalogue record for this book is available from
the British Library.

Vanessa Cutler has asserted her rights under the
Copyright, Design and Patents Act, 1988, to be
identified as the author of this work.

This book is produced using paper that is made
from wood grown in managed, sustainable forests.
It is natural, renewable and recyclable. The logging
and manufacturing processes conform to the
environmental regulations of the country of origin.

Cover design: Sutchinda Thompson
Page design and layout: Susan McIntyre
Editor: Kate Sherington

Typeset in 10.5 on 14pt FB Californian.

Printed and bound in China.

COVER IMAGES: Details p. 12, p. 22, p. 6

TITLE PAGE IMAGE: Kirsteen Aubrey and Professor David Crow, *Hammer 3*, 2011. Sub-surface-laser-engraved optical glass. *Photo: Tony Richards.*

CONTENTS PAGE Details from p. 65; p. 115; p. 114; p. 109; p. 68.

Contents

Vanessa Cutler, *Wheaton*, 2011.
Water-jet-cut glass, 16 x 11 x 33 cm
(6¼ x 4½ x 13 in.). *Photo: Vanessa Cutler.*

Acknowledgements

I would like to thank all the artists and companies who have been so open and helpful during the writing of this book, for the use of images and for the valuable information they have supplied.

Particular thanks go to Swansea Metropolitan University, Professor Mark Ganter, Glen Gardner of the ExOne Co., the water-jet companies KMT Waterjet, OMAX and Flow and Tony Marino at Advanced Glass Technologies.

Introduction

Artists are forever looking for ways to make more sophisticated or complex work. For some, it is not enough to work with just the hand-carried toolbox, whatever tools or materials can be found in the studio, and traditional techniques. Artists are increasingly reaching out to industry to utilise methods that were not easily available until recent years. Alongside the Gelflex, wax and other traditional tools of the studio, drawing and modelling software is gaining prominence and changing artists' working methods. The glass artists showcased in this book all include digital and/or industrial technology in their working practices.

It is not just that digital working methods suit the production of complex forms: they are also economical. Processes are faster and in some instances are cheaper in terms of the method of manufacture. The processes described in this book can push artistic development and allow the use of new materials: for example, the cutting of singular or multiple forms by water-jet, the production of complex imagery for sandblasting by vinyl plotting, or the use of laser technology to replicate a drawn idea in a 3D form. The processes are often more efficient and accurate than using hand tools. Software packages such as Illustrator, RhinoCAD and SolidWorks help with generating ideas, and also technical requirements such as turning a dot matrix file (a JPG file in which the designed image is made of 'dots') into a vector file (in which the dots are joined to form an outline), this being the required format for many of the processes.

In recent years, the cost of applying these techniques has lowered. Within the UK, there are now commercial and educational enterprises that give artists access to equipment, such as the Creative Industries Research and Innovation Centre (CIRIC) in Swansea, Creativity Works in Sunderland and Metropolitan Works in London. Some commercial firms are quite willing to allow glass artists, or designers working in any medium, to use their equipment to achieve their goals. This book provides guidance on how to engage with these firms and will give you an insight into the developing world of industrial equipment.

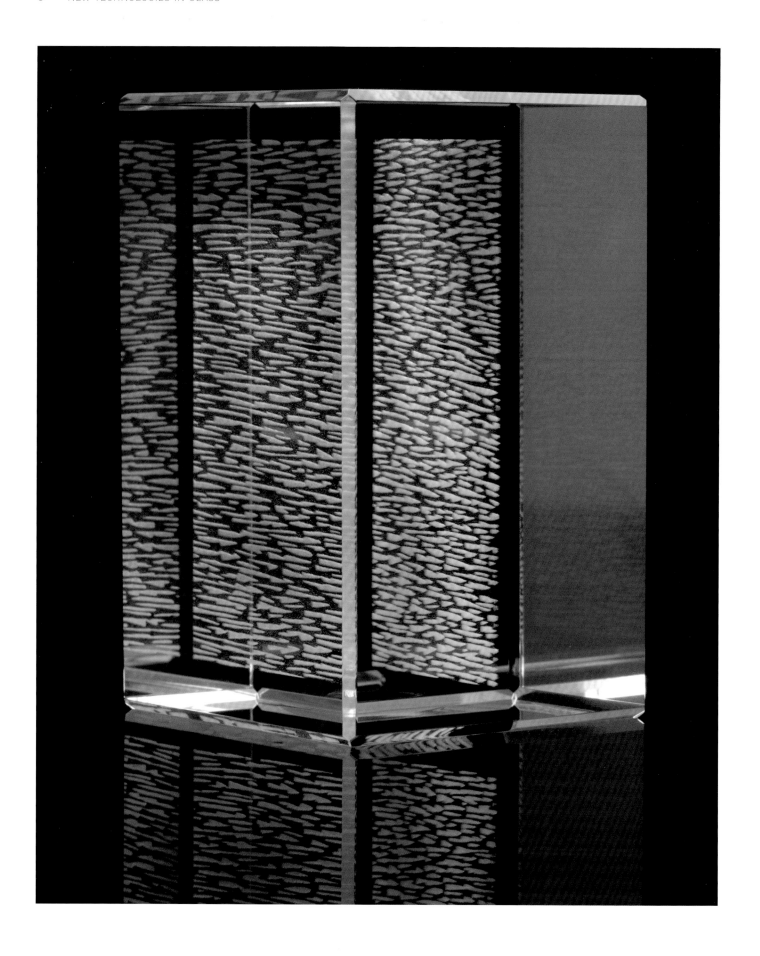

1

Digital tools

The addition of digital tools to the glass artist's repertoire is evolving, with artists combining traditional haptic skills with the use of drawing and machining software to capture the essence of a form, whether it is a fluid drawing or a geometric shape. The application of this software to individual practice relies on a more systematic approach, rather than an intuitive one, and getting to grips with these new tools requires a significant and ongoing commitment of time, along with access to the technology for ongoing experimentation. As with any new techniques, the learning process can be quick or slow, depending on the time spent investigating and applying what has been learned.

This chapter will describe some of the different types of software being used by glass artists today and how these are useful in the development and manufacture of artwork.

The challenges of new tools

Glass artists who have decided to use new technologies must learn how to transfer an idea on paper into a computerised form that will convey the aesthetics they envision. Developing these new thought processes involves a period of discovery and experimentation. Some will find a computer to be a helpful aid and it will become an intrinsic element in their ongoing practice; for others, it is a tool they must master in order to meet a set objective, such as to produce an effect in a particular work. For example, glass artist Kirsteen Aubrey, known for blown and kiln-cast objects, has produced new work using a sub-surfacing laser, which required a new approach. Some artists have developed an instinctive and intuitive approach to using digital tools. Examples will follow throughout the book.

Many artists acknowledge that understanding how to use new software is important for them to evolve their making process. The main challenge in the use of these new programs and processes is that different digital tools use or produce different file types. For example, in Aubrey's *Icicle Garden* (opposite), understanding the files and software required for the project was a necessary prerequisite to success,

OPPOSITE Kirsteen Aubrey, *Icicle Garden II*, 2011. Sub-surface-laser-engraved glass, 8 x 5 x 5 cm (3¼ x 2 x 2 in.). *Photo: Tony Richards.*

because without creating or supplying the correct files, the production of the work would not have been possible. Throughout this text, I have indicated which file type should be created, produced or used, to avoid confusion. The file types produced by some of the key software packages are introduced throughout this chapter.

Artists sometimes find the different terminology used in glass machining confusing. The use of engineering terms, such as 'nesting' and 'orifice', rather than 'placing' and 'aperture', are part of the language of this technology, just as hand-drawing or hand-cutting terminology has always been part of the traditional studio language. These new terms will become familiar with time and over the course of this book. A glossary is provided at the back of the book as a quick and easy reference (see pp. 126–7).

Software for drawing and modelling

Drawing and modelling software, also known as CAD (computer-aided design) software, is used to develop and create drawings, alongside the hand-drawings in your sketchbook, to resolve ideas and forms into 'layers' of information. These digital designs will be exported in the form of vector files and then converted into CNC (computer numerical control) code, which machines can read to manufacture glass artworks. These digital files are working drawings, whether 2D or 3D, for a manufactured piece of work.

Artists can use a variety of software packages to produce the files required. A drawing file created in any of the programs described must be exported as a DWG or DXF file, or sometimes an STL file, depending on the requirements of the machine you will be working with. These are all forms of vector files, which are images made up of 'vectors' or lines (also called paths), leading through specific points, which represent the outline of the image. The same goes for any dot matrix file, also called a 'raster' file (a JPG or TIFF, for example) that has been imported into CAD software. The software of the machines being used to manufacture your work will read the vector files as CNC code. For an example of CNC code, see p. 17.

Some of the types of software you are likely to use for drawing, modelling, creating vector files and producing CNC code are described in the following pages. Note that other brands of software, not covered here, are also available.

ADOBE ILLUSTRATOR

This drawing software is available as a standalone program and also within Adobe Creative Suite CS4 and CS5. It doesn't have the same capabilities as other software in terms of streamlining design processes, such as documentation and manufacturing, but it is a powerful graphics program that can create vectored 2D and 3D images. For glass artists, Illustrator offers great flexibility in creating designs. It is used widely within the creative industries.

Many artists and craftspeople use the Adobe Creative Suite in some form or another. But note that Photoshop will not export or save a JPG image as a DWG file, as this feature is not part of that software – Illustrator will do this, because

Illustrator allows you to export an image as a vector file. What Illustrator cannot do is make CNC code for the machine. The DWG file from Illustrator is the starting point of the process, from which you move into the manufacturing and processing terminology of making a glass form.

There are other Adobe software packages available, such as Freehand, but in most instances Adobe would advise you to use their latest software package, currently CS5, as it will contain the best and most up-to-date features to aid the generation of artwork. (See www.adobe.com.)

Note: If an initial drawing is scanned into Illustrator as a JPG, it needs to be traced manually rather than by using the Live Trace button. With manual tracing you can modify and make the shape as close to your requirements as possible, but the Live Trace will pick both sides of a line that has been drawn and usually results in more time spent tidying up the file.

AutoCAD

This is a software package geared towards the engineering, manufacture and architecture sectors, which allows for 2D and 3D drawing. For artists, it is not necessarily the preferred software, but is very good for creating vector drawings and easily transferred into software used by the various machines discussed in this text. Artists such as Jessamy Kelly, Nicky Schellander and Thierry Bontridder have used the program for designing glassware for Edinburgh Crystal and Dartington. (See www.autodesk.com.)

Example of an Illustrator file.
Photo: courtesy of Catrin Jones.

AutoCAD drawing file for *Luna*. *Photo: courtesy of Jessamy Kelly.*

AutoCAD drawing file. *Photo: courtesy of Thierry Bontridder.*

ABOVE **RhinoCAD drawing file.** *Photo: courtesy of Tavs Jorgensen.*

RIGHT **Screen render and wire frame model for a glass form.**
This 3D drawing demonstrates an idea for one of Cane's *Ripple Landscape* pieces. *Photo: courtesy of Cane Kali.*

RhinoCAD

RhinoCAD is another good software package for 2D and 3D drawing and is very much geared towards creative practice, being used by jewellers, architects and design companies. It allows the initial fluidity of dot matrix files to be converted into vector files. Many of the artists mentioned in this book are using RhinoCAD; Michael Eden and Shelley Doolan, in particular, use it in a very comprehensive way for 2D and 3D work, as it has the ability to produce 3D designs that can then be broken down into 2D images. It can save STL files for machining and DWG files for laser and water-jet cutters. It is extremely multi-functional and its files can be moved between different programs with ease. It also allows for add-ons or additional software attachments. (See www.rhino3d.com.)

SolidWorks CAD

This is a more comprehensive software package, geared towards 3D modelling, simulation and documentation. Companies such as Flow have teamed up with SolidWorks in the production of software for their five-axis water-jet machine. This software allows a wider user base, because it is a common software package among designers and engineers who are using these technologies in their production. It also has a deeper, complex and more focused understanding of the transition from 3D drawing to the actual 3D parts being produced, and matches the tolerances required by some machining companies. (See www.solidworks.com.)

ABOVE AND LEFT **Experimental form-finding in SolidWorks.** *Photo: courtesy of Shelley Doolan.*

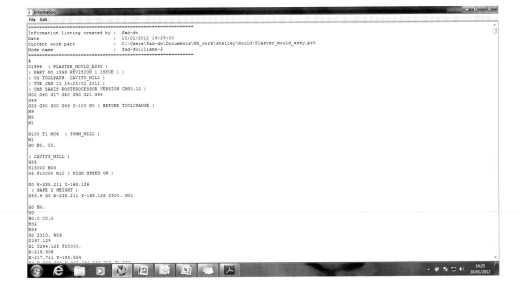

CNC code produced in SolidWorks.
Photo: courtesy of Swansea Metropolitan University.

Google SketchUp

SketchUp is a 3D modelling program and the basic version is available as a free download. It is ideal for drawing designs for artworks or for visualising a site-specific work in its space. It is also good for presentation purposes, in terms of visualising and explaining concepts, because you can represent your ideas in a three-dimensional way. Use SketchUp Pro to export DWG or DXF files. (See sketchup.google.com.)

Things to note

RhinoCAD, AutoCAD and SolidWorks all enable designs to be created as 2D and 3D vector forms. Some artists will use this software to generate the 3D form of the object, to aid their overview of the final work, before breaking it into 2D forms.

It is worth noting that some software packages have both a Mac and PC version. It doesn't really matter which system you use. The only thing to bear in mind is that machine software, for example that of the water-jet and laser cutter, is often Windows PC-based, so occasionally the files can alter slightly when transferred from one platform to another. Before transferring an image file, it is important to check that everything is clear and consistent in terms of the scale and formatting of your drawing, and to make sure that all points are closed.

If you are working in very current software such as AutoCAD 2010, you may need to save the file to an earlier format such as AutoCAD 2006 if a company's machine can only read the older version. The company will tell you which files they require.

Alongside the well-known programs listed, there is also software that can be downloaded without having to purchase a licence agreement. This is handy if it may only be used for one particular project. Some companies allow trials of their software, which enable you to investigate the program to see whether it might be useful for future applications.

Software for cutting and profiling ('nesting')

The drawing you have made in the software just described is the part or shape that is to be cut or engraved from the glass. This part now has to be located or placed in the material being cut. This is called 'nesting' and is done using CAD/CAM software, based on the vector file. The instructions for the machine (in terms of how to cut the designed object and how it is nested in the glass) are saved as CNC code, which is then read by the machine's controls for machining to occur. Note that the key interface that allows you to have your work manufactured is the vector file (see pp. 10–14).

So, to clarify: once drawing files are exported as vector files, they can be imported into a CAD/CAM program such as IGEMS or Lantek Expert, where you determine the nesting and convert the file into CNC code. The code is then read by the machine, such as the laser cutter or water-jet cutter, to carry out work on the glass. Every machine will have its own software, which allows CNC code to be inputted. (See www.techniwaterjet.com, www.omax.com, www.waterjetsweden.com, www.finecut.se, www.flowwaterjet.com, www.kmtwaterjet.com, www.bhrgroup.com.)

2D drawing in IGEMS for *Intertwine* and *Crackerjack*.
Photo: courtesy of Vanessa Cutler.

Nested 2D image in IGEMS for *Intertwine*. *Photo: courtesy of Vanessa Cutler.*

IGEMS

Glass artists are unlikely to use this software to design, as it is aimed at people working in engineering situations. Instead, it is likely to be used by the machining companies who manufacture the work, and specifically by machine operators.

The software program IGEMS is used for water-jet cutting, laser-cutting and plasma processes and is similar to AutoCAD. The main difference is that it can manage nesting (being able to fit multiples of a drawn part or form into a predetermined sheet of material). The software has its own parameters for a variety of materials, thicknesses and speeds, offering a range in cutting quality that can be adjusted depending on the needs of your work; for example, sometimes you don't need a perfect cut, especially if you are adding additional processes afterwards, such as polishing or grinding.

IGEMS Software AB, based in Sweden, has worked closely with manufacturers to ensure that its software meets the requirements of its markets (see www.igems.se). The software supports a variety of files. Most importantly, it accepts DWG and DXF files exported from RhinoCAD, Illustrator, SolidWorks and other packages such as Mastercam, CorelDRAW 3 and Alias. If working in any of these 3D software packages, remember that IGEMS is geared towards 2D drawings, or a single flat image. It prefers a single layer image drawn on one layer to multiple layers.

For those glass artists interested in knowing more, IGEMS can be downloaded for a trial period. The drawing files cannot be saved, but a trial would allow the artist to understand the interfacing software that transfers their initial drawing into the cutting program. However, the software is more relevant for the machine and its operator than for the design of glass forms.

2D drawing in Lantek: preparatory work for *Intertwine* and *Crackerjack*. *Photo: courtesy of Vanessa Cutler.*

2D drawing in Lantek for *Intertwine*. *Photo: courtesy of Vanessa Cutler.*

LANTEK

Lantek is a similar package, produced by another company, which can convert DWG and DXF files into CNC code. It too is aimed more at those operating and programming the machines. However, artists who have access to such machines may have the opportunity to work with the software.

Again, Lantek is compatible with all software packages that export vector files such as DWG and DXF. It offers, like IGEMS, the ability to nest parts into sheets and has its own adaptable parameters for speed, abrasive flow and type of material being cut. (See www.lanteksms.com.)

CNC code

CNC means 'computer numerical control'. As described previously in this chapter, a drawing file has to be transferred into an intermediary program such as IGEMS or Lantek to determine nesting instructions, and from there into CNC coding, in order for a machine to carry out its task of cutting.

CNC code allows the machine to process the image in terms of coordinates. The first lines for the coding are the set-up of the machine, giving information about the type of garnet, the pressure and the sizes and diameters of the nozzle and orifice to be used. All of these contribute to, for example, the cutting parameters, the speed at which the cutting head will move and the amount of abrasive in relation to the type of material being cut. The first 16–20 lines of the code give the standard set-up, before moving into the coordinates of the work being cut.

It is very unlikely that an artist will need to work directly in CNC code, but it is good to be able to understand and check its basic properties.

An example of CNC coding and what it means

```
%
O175 (NAME: VANESSA 100 FLOAT LAYER)
N10 (MTR:Glas)                          material
N12 (THK:20)                            glass thickness
N14 (HPR:3500 BAR)                      pressure
N16 (ABR:GMA Garnet 80)                 abrasive mesh size
N18 (ABG:250 G/MIN)                     abrasive flow
N20 (ORF:0.25)                          orifice size
N22 (TUB:0.76)                          nozzle size
N24 #501=0.5(DELAY NOZZLE ON)
N26 #502=0.5(DELAY NOZZLE OFF)
N28 #503=10 (STATIONARY)                piercing times
N30 #504=6 (CIRCULAR)                   piercing times
N32 #505=10 (LOW STATIONARY)
N34 #506=10 (LOW CIRCULAR)
N36 #101=20 (Z UPPER DIST)
N38 #111=0 (Z-REFERENCE)
N40 G0 Z#101
N42 (HEADS:1)
N44 T1 S1 D1
N46 G90 G40 G54
N48 M0 (LOW PRESSURE)
N50 (P:19mm 100 transporter)
N52 G0 X144.845 Y50.231                 coordinates
N54 G0 Z#111
N56 M3 M7
N58 G1 F273 X145.545 Y50.231
N60 G2 I-0.7 J0                         multiple circles N60–N78
N62 G2 I-0.7 J0
N64 G2 I-0.7 J0
N66 G2 I-0.7 J0
N68 G2 I-0.7 J0
N70 G2 I-0.7 J0
N72 G2 I-0.7 J0
N74 G2 I-0.7 J0
N76 G2 I-0.7 J0
N78 G2 I-0.7 J0
N80 G1 X144.845
N82 M9 M5
N84 G4 X#502                            X-axis
N86 G0 Z#101                            Z-axis
N88 G0 X123.269 Y25.772
N90 G0 Z#111
```

KEY

T	=	water
S	=	air
F	=	speed
D1	=	cutting head 1 (single-head machine)
X	=	X-axis (left to right)
Y	=	Y-axis (front to back)
Z	=	Z-axis (top to bottom; the distance from the bottom of the nozzle to the top of the material)
G	=	direction of the head if on the line to the left or right of the line drawn
J0	=	circular low, relating to piercings
M	=	start/stop
M3	=	start water
M7	=	start pressure/air
M5	=	stop water
M9	=	stop pressure/air

Screen renders (3D computer-generated drawings) of *Gyroid* forms; pieces are made to order.
Photo: courtesy of Bathsheba Grossman.

Artists using digital tools

Artists including Bathsheba Grossman, Marcel Wanders, Philippe Garenc, Tavs Jorgensen, Michael Eden, Shelley Doolan, Geoffrey Mann and Heatherwick Studios are all using software such as RhinoCAD, Grasshopper, T-Splines, SolidWorks and Mastercam to help in the manufacture of work. Other artists, such as Aimee Sones, Colin Rennie and Jeffrey Sarmiento, use software to develop forms and imagery.

MICHAEL EDEN

Michael Eden is a trained ceramicist who, through research, has come to apply digital technology in both his glass and ceramic work in a very unique way. He uses digital software to produce work that is sent to a French company, Axiatec, for 3D printing. He has worked in glass for Established & Sons and was commissioned to produce a series of vases in collaboration with the Italian company, Venini. His initial design was produced in RhinoCAD in the form of 3D renders (graphics) before being formatted into vector files, from which a wooden mould could be made. The glass-blowers then worked from these moulds. It was a successful marriage of 3D software with the traditional materials and skills of Italian craftsmen. Michael's interest has been in the extension of the traditional toolbox via software and new technological developments. As with most artists working digitally, he does not see either hand or digital work as being superior to or more valuable than the other.

ABOVE Michael Eden, *Audrey Light*, 2010. This design uses the classic beauty Audrey Hepburn's profile to create the familiar infinite illusion. All components of the light are hand-blown and together with a historical source of inspiration, enable the designer to portray age-old ideas and methods in a modern and exquisite form. Hand-blown Venini glass, powder-coated steel ceiling fixing, steel suspension cable, 52.5 x 26.5 cm (20¾ x 10½ in.), cable 30 cm (12 in.). *Photo: Peter Guenzel, courtesy of Established & Sons.*

LEFT Rhino CAD drawing files for the *Audrey Light*. *CAD rendering by Michael Eden.*

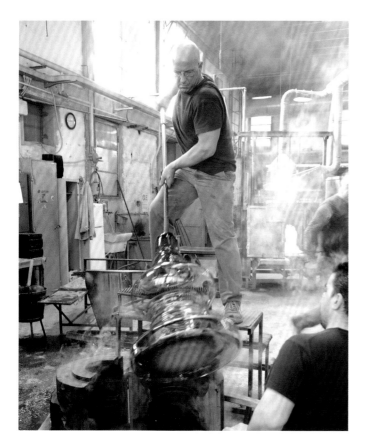

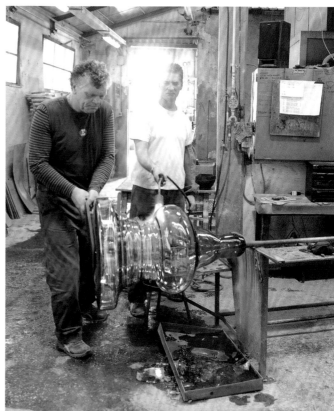

ABOVE LEFT Manufacture of the *Audrey Light*. Here, the blown glass is removed from the wooden mould. The glassblower gathered and blew the glass into a balloon shape, which was then lowered into position, the two parts of the mould being closed around it. The glassblower continues to blow whilst turning the blowing iron, ensuring that the form develops symmetrically and follows the interior profile of the mould as closely as possible. *Photo: courtesy of Established & Sons.*

ABOVE RIGHT A section of the glass is reheated in order to refine a detail before the glass is removed from the iron. *Photo: courtesy of Established & Sons.*

RIGHT Michael Eden, *Audrey Vase*. Hand-blown Venini glass: outer glass amethyst, inner glass opaline red with matt Carrara white marble, 33.5 x 36.5 cm (13¼ x 14½ in.). *Photo: courtesy of Established & Sons.*

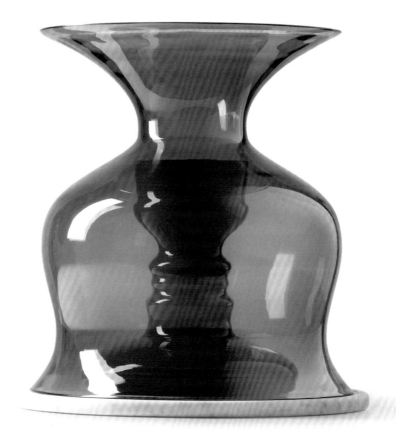

TAVS JORGENSEN

Tavs Jorgensen is a designer and researcher at Autonomatic, a 3D digital research group at University College Falmouth. He is part of group of makers and designers who have pushed ahead in the development of digital tooling within studio practices. He has undertaken several projects that utilise digital technology, such as a data glove and micro-scribe, reconfigurable tooling, laser-cutting, milling and 3D printing (see glossary for definition of terms). He has investigated the use of mechanical processes and CAD interfaces to help develop a more intuitive approach and offer flexible production methods that can cross between digital and hand production.

As for many makers, the ability to capture movement within an object is a challenge for Jorgensen. For his *One Liner* project, he used a micro-scribe to capture the drawn movement of a line in space and manufactured it into a glass bowl. He mapped the data of the invisible form, transferring it into code so that he could use other technologies to manufacture the form.

Tavs has looked at methods of production that can be utilised over and over again. One project investigated the reconfiguration of tooling for a pin-mould former. Drawing and controlling his design using RhinoCAD, he made a former that could be replicated time and time again. The pin mould and formers used for *One Liner* were produced using technology he had applied previously, such as laser-cutting. This helped him to manufacture the formers easily and affordably.

BELOW LEFT Tavs uses the micro-scribe to capture the line and transfer it into a form. Tavs undertakes the investigation of different methodologies in the manufacture of work and the ease of applying his digital processing techniques economically to a maker's practice. *Photo: courtesy of Tavs Jorgensen.*

BELOW RIGHT Set-up of Tavs' pin mould; each of the pin heads can be raised or lowered depending on the depth of the slump he wants in the glass. The paper beside the mould is the CNC code and coordinates for each pin head. *Photo: courtesy of Tavs Jorgensen.*

BOTTOM RIGHT The steel-machined former that the glass is slumped over, to create pieces like those on p. 22. *Photo: courtesy of Tavs Jorgensen.*

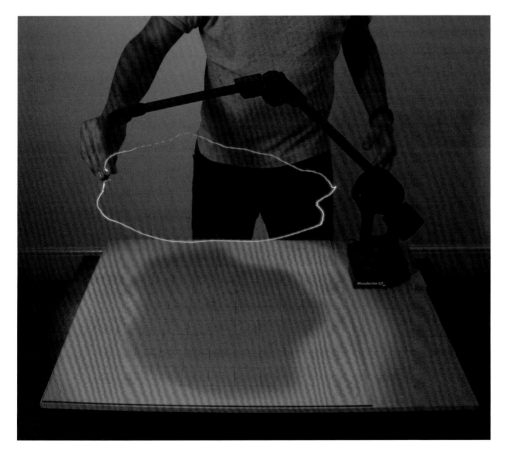

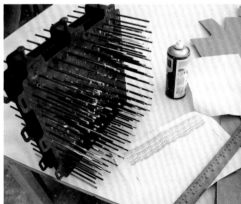

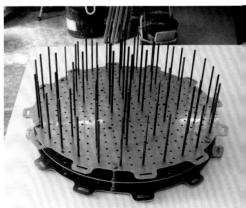

Tavs Jorgensen, *One Liner*, 2009. Slumped glass (a micro-scribe digitiser was used to design the steel former), 55 x 55 x 18 cm (21½ x 21½ x 7 in.). *Photo: Tavs Jorgensen.*

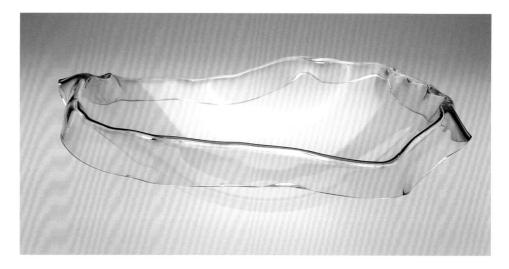

Tavs Jorgensen, *Large Grey Glass Bowl*, 2011. Slumped glass produced using a reconfigurable pin mould, 46 x 46 x 16 cm (18 x 18 x 6¼ in.). *Photo: Tavs Jorgensen.*

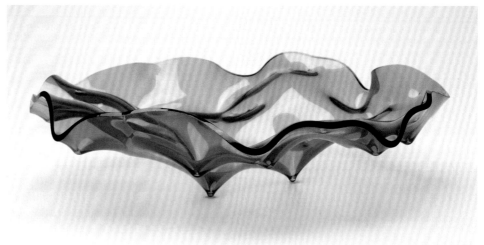

Tavs, like Shelley Doolan and many other artists, has found the software Grasshopper, along with RhinoCAD, to be a useful digital tool in making forms for manufacture. For his pin mould, the virtual form was generated in Grasshopper and shaped in RhinoCAD. The height definition of a form is also something that can be generated via software or by manual intervention. This project seems to have come full circle in that analogue experiments into the way the pins can shape the glass are now taking place. Technology is the toolmaker, enabling the designer-maker to build and create affordable formers. However, Tavs is also aware of the need to let the glass do what it wants to do and respond to that. He recognises differences in what he can do when handling different materials, such as glass and ceramic, in his processes of production. Glass can be moulded by heat and slumped into or over a form, such as his pin mould. Ceramics can be pressed and moulded, usually into a digitally manufactured mould, prior to firing.

There is an element of serendipity to Tavs' work, in that he works with processes that present themselves as he develops his practice. He is now investigating 3D printing (see p. 95). His interest concerns the affordability of using technology alongside his standard practice and traditional studio tools.

WANDERS, HEATHERWICK AND SONES

Marcel Wanders used digital technology to capture movement we don't normally see for his *Snotty Vase*, which investigated the different viruses that come from our noses. Thomas Heatherwick has used software in the development of objects, working on commissions in a variety of materials. The ability to design fluid and rigid forms in both two and three dimensions offers lots of scope, as does being able to cross over between disciplines, without having to redraw or re-program for each technological process.

Aimee Sones's project, *Landscape Lollipops*, consisted of creating sugar candies based on rapid-prototyped models of the topography around Corning, NY. She made the candies in sugar through rapid prototyping and kiln-cast the forms using Bullseye billets. The three images on the right demonstrate the use of Google to view the topography of the area and how Aimee had to use a number of different programs to vector the form into the imagery. Her use of sugar was a cheap alternative prior to casting glass.

Aimee explains how the use of digital software and machining allowed her to produce forms in different ways without losing data:

Three-dimensional printing or rapid prototyping allows me to make exact representations of specific places to scale in order to transform them into works of art. Without these technologies, the cost of making art based on an accurate demonstration of a place would have put the possibility of creating work like this out of my reach. Once printed, the models can then be recast in almost any media, glass and metal having a much longer material life than the three-dimensional printing material originally used.

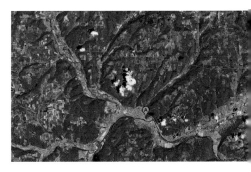
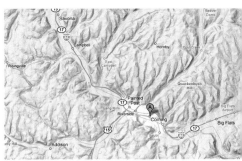
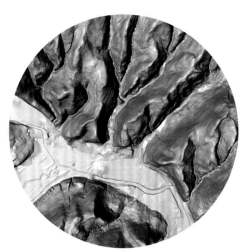

ABOVE Developments for Aimee Sones' *Landscape Lollipops*. These are the original maps on which Aimee based her designs.
Photo: courtesy of Aimee Sones.

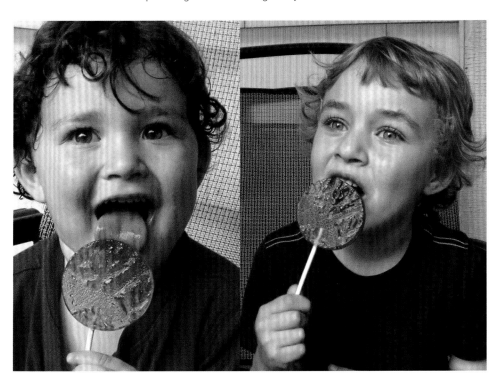

Aimee Sones, *Landscape Lollipops*, 2010. Sugar, 17 x 7.5 x 1.2 cm (6¾ x 3 x ½ in.) each. Images were taken from digital elevation models of the terrain and made into lollipops.
Photo: courtesy of Aimee Sones.

Aimee Sones, *Landscape Lollipops*, 2010. Sugar, 17 x 7.5 x 1.2 cm (6¾ x 3 x ½ in.) each. *Photo: Aimee Sones.*

The work could have been carved by hand based on maps and elevation models, but something would change through that translation; there is something to be said about having an exact scaled model rather than an invented form based on my own interpretation and memory. It is in the use of this technology that a new type of interaction between the work and the audience has been established; it leaves the work open for the viewer to make their own connection with the true landscape by removing the filter that my hand would have placed upon it. While the landscapes will no doubt continue to change over time, it is possible that the glass model could remain intact for thousands of years to come, a permanent record of the landform from the present day. Advances in technology have made it possible to immortalise a visual representation of places that I have visited and have an inherent familiarity with.

Many artists are working with visual representation, using mapping terrain software along with 3D cameras and 3D scanners. Making something three-dimensional from two-dimensional imagery is something that will become even easier to do in the next few years. And with the design software now available, often with free trial downloads, you can even do this without having to directly input a drawn image.

Collaborating with companies

In his writings, Robert Knottenbelt discusses how difficult it was in the 1980s to find the right people to undertake his work. He encountered the same difficulties in production that we may have today when using an engineering company or fabrication shop. Leaving a job totally up to them to process might result in glass with a different finish to the one anticipated. The attitude and response of a company to the work you are developing can be varied: some may take the work on as a personal challenge, but to others it is just a commercial job.

Twenty years ago, the software required to produce Knottenbelt's glasswork (see p. 27) was only available to the trained engineer in specialised fields and it was bulky, complex and time-consuming. Nowadays, software for the design and manufacture of work is much quicker to use and more widely available, enabling artists to be more engaged in the process. The ability to process data continues to become faster and more accessible: now there are even phone applications such as Tridimension, which enables an iPhone to act as a 3D scanner.

As with many things, it is likely to take time for this kind of technology to become widely popular. For glass artists, the use of a phone application to produce glassworks will take time to filter into general practice. It is not something that will be part of every glass artist's practice, but a few may try, especially where their work is geared towards digital engagement. For example, one can imagine Mark Ganter and Philippe Garenc using such applications in future works.

Commercial companies mention that one difficulty they experience in working with artists is making them appreciate that everything they do has a commercial

cost and that they must log the time spent machining, cutting and programming, as well as overheads. Every time an idea is changed, there is a cost, and often an artist's project is a low priority in the job queue. As artists, we invest so much personal time that we sometimes forget our project is not necessarily the primary focus of the company undertaking the work (though I must stress that this is not always the case).

Also, we often make the assumption that a company knows what finish or effect we require. Drawings and instructions are vital for the person at the bench or machine to follow, so these shouldn't be changed in mid-process unless you are willing to underwrite the cost. Artists such as Caroline Rees and Christopher Ries have built a relationship with companies over time: they make their objectives concise and clear for all those who might have to handle the work during manufacture. (Christopher, of course, is quite unique in that he will go and work with the machinery at the factory himself.)

Here are guidelines you can follow to make the manufacture of work easier.

- Remember to clearly outline what you need and set a budget. Don't expect an expert's time for free.

- Learn the basics to produce the computer files the company needs or source someone to do them for you. The more the company has to do for you, the more the cost can increase. In some cases, companies may be willing to help if a project will aid their own research and development. Some companies just need a drawing; in other cases, a specific digital file type might be required. Most companies will ask for a vector file. The exact format will depend on what their operators use, but DXF, DWG and AutoCAD files are standard within industry.

- If possible, be available when the work is being carried out, so you can deal with any queries as they arise.

Fabrication labs

In recent years, 'fab labs' – small-scale digital fabrication centres – have begun to appear more often within creative environments, allowing artists to directly access facilities such as CNC routing machines, laser cutters and specialist computers. The centres offer anyone access to equipment that artists may not necessarily have in their own studios.

For example, Haystack, on Deer Island in Maine, USA, has set up such a lab, working with MIT's Center for Bits and Atoms to provide a facility that allows traditional craft skills to be combined with digital technology. There is also a fab lab in Manchester in the UK, offering 3D printing, laser cutting, routing and access to vinyl-plotting machines. The ethos of these places is to offer access and advice for using these machines in your practice.

2

Water-jet cutting

Traditional methods of cutting glass all work to the same principle: create a score line with a cutting tool, then use a small amount of oil and the manual strength of your hands to break the glass. The quality of cut varies. The edges are sharp and fingers can often be cut. Cutting complex curves requires several attempts and right angles can't easily be achieved. The manual cutting of shapes inside other shapes is difficult and time-consuming, with glass artists finding ways to create these forms by overlapping and joining glass together, using processes such as fusing. Overall, the process involves lots of wastage in material and requires the use of a variety of machines and hand tools to achieve the shape, not to mention a great deal of time spent on each individual shape.

Master glaziers already have systems and methods of cutting glass that may look simple to the layperson, but have been refined by years of continual cutting and experimenting. Some use devices such as the Taurus saw, an electric-powered, diamond-coated, water-fed bandsaw that enables you to cut an external shape, but it is limited in terms of the shape, size and thickness it can cut. Tools such as this are geared towards the small glass artist's studio. In commercial cutting and processing companies, automated cutting machines such as diamond-coated saws and discs are often used to cut, shape, bevel and polish glass.

The water-jet machine makes the cutting process cheaper and easier still and opens up new possibilities for cutting complex glass forms. In many ways, the introduction of the water-jet has been brought about by commercial companies looking at methods of production for multiples, aiming to cut ever more complex forms in ways that will minimise material waste and production costs. The machine can cut internal and external shapes out of glass with an accuracy that allows multiple parts to be identical and allows for intricate shapes that would be difficult to achieve manually or with traditional tools. Companies such as the Italian firm Fiam, which produced the classic 'ghost chair' designed by Cini Boeri, have used the water-jet to great effect, utilising the benefits of the technology to achieve accuracy of cut.

Water-jet machines have been used for everything from cutting tomatoes, titanium and chocolate bars to kidney surgery and weapon disassembly. They have been around since the 1970s; in the 1990s, Robert Knottenbelt, an artist based in

OPPOSITE Robert Knottenbelt, *Tower Zero*, No. 1 of *The Satellite* series, 1991. CAD/CAM-designed glass, water-jet cut, sandblasted, acid-polished, silicon glues, 61 x 42 x 1.2 cm (24 x 16½ x ½ in.). Held at the Kunst Museum, Dusseldorf.

Photo: Terence Bogue, Melbourne, Australia.

Robert Knottenbelt, *Totemic Fish Contemplating a Persimmon*, 1988. CAD/CAM-designed plate glass, sandblasted, acid-polished, silicon glues, 80 x 40 x 1.2 cm (31½ x 15¾ x ½ in.). Held at the National Gallery of Australia. *Photo: Terence Bogue, Melbourne, Australia.*

An abrasive water-jet cutting through laminated glass.
Photo: Flow International Corporation.

Australia, was one of the first to apply the process creatively in glass. Since then, glass artists have made use of water-jets to economically cut multiple shapes, singular unique items and commercial shapes such as Christmas decorations.

How does a water-jet machine work?

As its name implies, a water-jet machine projects a stream of water on to a surface to cut it. Water is pumped at high pressure through a nozzle; the volume and pressure of the water and the diameter of the orifice control the power of the water-jet. For cutting hard materials, an abrasive may be added to the water. The cutting plan for the design is produced in the form of a vector drawing, which is transferred into CNC code. The code, in turn, is read by the machine in order to produce the shape required (see pp. 10–17).

For cutting hard materials such as metal, ceramics and glass, abrasive is added to the water. The type of abrasive used varies from aluminium oxide to silica sand. Within the glass industry, garnet (a group of minerals with a coarse texture) is the preferred abrasive, but olivine (a hard stone from mines) can also be used.

The grit sizes used are 80-mesh, 120-mesh, 200-mesh and 220-mesh. For the cutting of glass, 120-mesh produces an excellent edge. However, if you go to machining workshops that predominantly cut metal, they will use 80-mesh, which is coarser but can still achieve a good effect if the flow of abrasive and speed of the cut is considered carefully. The other mesh sizes are good for milling and surface abrasion (see pp. 50–2), but do not have the strength to pierce glass and metal.

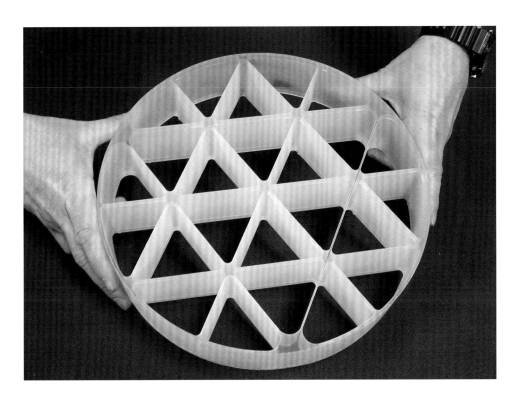

Industrial glass that has been cut with an abrasive water-jet. This Zerodur® glass of 3.5 cm (1 1/3 in.) thickness was cut into a honeycomb shape for light weighting (reducing the weight of the glass whilst still maintaining strength).
Photo: Mohammed Hashish.

Benefits of water-jets for glass artists

The benefits of using this technology in your practice can be summed up as follows:

1. Complex shapes can be cut quickly and efficiently.

2. The accuracy and quality of the cut is better.

3. Multiple shapes can be cut within a single sheet of glass and more internal shapes cut within those – this is not possible manually.

4. The water-jet is cost-effective in terms of saving labour and reducing wastage of material.

5. It has the ability to cut glass up to 300 mm (12 in.) thick.

6. It can cut lines within a sheet of glass to give an outline (external cutting).

Initially, artists used water-jets to cut irregular shapes of flat glass for stained-glass commissions. Now they are using them in a variety of ways: for mould-making, cutting kiln shelves, to make steel formers for slumping, to cut materials such as foam and high-density fibreboard and for deep sandblasting. The machine will cut most materials (except toughened glass), no matter how complex, thick, thin or small. Thick sheets of fused glass can be cut quickly and easily into simple or complex shapes, both internally and externally. It allows you to jigsaw-fit complex shapes together (see p. 40) or create surface decoration. Multiple shapes can be cut to exact dimensions.

Note that you still have to handle the material carefully after it has been cut, or it will end up broken and in the bin.

Vanessa Cutler, *Mast*, 2006 (detail). Example of a good-quality cut.
Photo: David Williams.

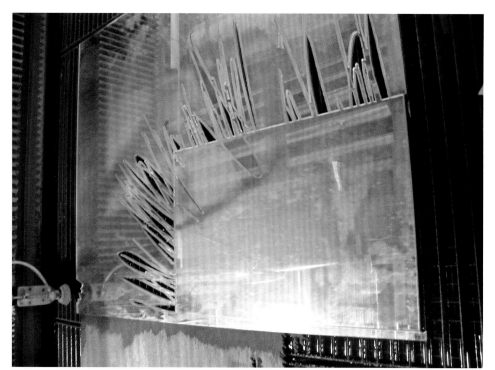

Cutting with a water-jet

A water-jet will cut glass that is 1–300 mm ($\frac{1}{20}$–12 in.) thick. The thicker the glass, the more careful consideration is needed in the process. For glass up to 60 mm (2½ in.) thick, the cutter produces a good finish. However, if you wish to use thicker glass, some further cold working might be required, as a taper may occur during cutting, making the underside of the glass slightly wider than the top edge. Taper refers to a slight angle of cut on the glass, caused by the jet travelling too fast so that it is not able to stay straight at the lower edge of the glass and drags behind, losing strength and displacing itself.

Two-, three- and five-axis cutting

Water-jet cutting machines are described by the number of axes the machine can travel along: for example, backwards and forwards, or side to side. A two-axis machine would comprise an x-axis and a y-axis, by which the machine could go forwards and back and side to side. A three-axis machine uses x-, y- and z-axes, the additional function being the ability to move up and down; sometimes the head of the machine is fixed, so the range of the z-axis cannot be adjusted while it's in motion.

A five-axis machine is multi-directional. It can both move and tilt the cutting head in fluid movements. On a five-axis machine, the cutting head can move on the x-, y- and z-axis, but also has the ability to tilt in a range up to 60 degrees, dependent on the a- and c-axis (the a-axis being the angle from the perpendicular and the c-axis being the rotation around the z-axis).

The capabilities of the five-axis machine as applied to the work of glass artists has not yet been explored fully. Currently, most cutting undertaken for artistic

ABOVE Vanessa Cutler, *Mast*, 2006. Laminated layers of glass cut by water-jet, South Shields Hospital cardiology department, 60 x 60 x 20 cm (23⅝ x 23⅝ x 8 in.). *Photo: David Williams.*

ABOVE RIGHT Water-jet machine cutting Esther Adesigbin's artwork *Scribbles*. *Photo: Vanessa Cutler.*

Both photos on this page show the delicacy of cuts required, the different types of glass used and the complexities of programming the machine is designed to cope with, from very fluid forms to angular geometries.

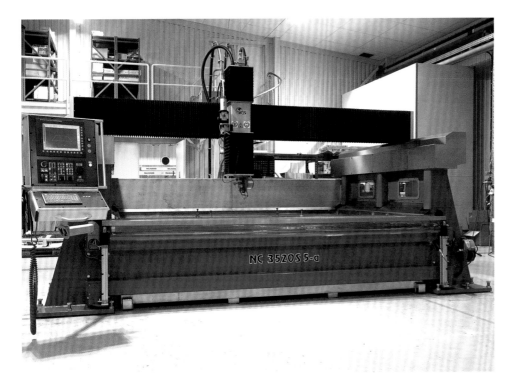

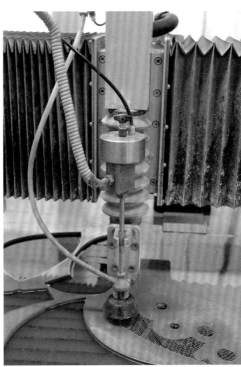

ABOVE LEFT Five-axis water-jet machine.
Photo: courtesy of Water Jet Sweden.

ABOVE RIGHT Water-jet machine
cutting head. *Photo: Vanessa Cutler.*

purposes is done on single-axis machines. There has been some research in universities regarding multi-axis machines and work with glass, the machines specifically being three-axis, with a static head not able to tilt and rotate. A few places do have a five-axis machine for research, such as the Rolls Royce Technology Centre at the University of Nottingham. Dr Janet Folkes undertakes water-jet research on the five-axis machine there, but it is not generally geared to creative activity or use with glass. The Harvard Graduate School of Design's architecture department has a six-axis robotic arm machine and there are companies in Europe and America that use five-axis machines to work with well-known glass companies such as Baccarat and Steuben.

3D drawing/modelling software is needed for work on two-, three- and five-axis machines (see pp. 10–14)

Drawing and modelling software

Whatever the type of glass to be cut, you first need an electronic image or drawing which represents the design. Images such as JPGs, for instance, need to be converted from a digital dot matrix file into a vector drawing in order for the file to be read by the water-jet machine. (See p. 11 about using Live Trace for JPG files.) Illustrator, RhinoCAD, AutoCAD and SolidWorks can all convert image files such as JPGs and TIFFs into DWG or DXF vector files (for more on vector files, see p. 10). Ideally, you would draw directly into one of these programs to create a vector drawing.

SolidWorks is used worldwide by designers who work with machining processes such as rapid prototyping and CNC machining. The benefits of this software are discussed in Chapter 1 (see p. 12) and expanded in the following chapters. It is

ABOVE LEFT Illustrator file for *Tree* by Catrin Jones, 2011. *Photo: courtesy of Catrin Jones.*

ABOVE RIGHT Design for glasswork by Shelley Doolan in RhinoCAD, to be cut on the water-jet machine, 2011. *Photo: courtesy of Shelley Doolan.*

The above figures show how two artists working in Illustrator and RhinoCAD respectively develop their ideas. Catrin imports a photograph into Illustrator and converts it to a vector file, while Shelley works directly in RhinoCAD to design the form. The difference between the two programs is that Illustrator is two-dimensional, so works with very fluid forms, while in RhinoCAD you can build fairly geometric work three-dimensionally and break it down into layers.

especially good for breaking down designs for 3D objects into layers and dissecting coordinates that can be translated into CNC code for the machinery. Water-jet companies such as Flow have teamed up with SolidWorks to enable artists to prepare their initial drawings in the same software that will be used for cutting.

Water-jet machine software

Once the vector file for the design is done, it has to be imported into the software that comes with the water-jet machine, which isn't usually something that the artist works with directly. This is the transition stage between idea and object – the means of communication between the drawing and the material that is being cut. This program is used to tidy, scale up and plot the cutting cycle, then create the CNC code that is read by the water-jet machine. The software may be Lantek or IGEMS (see pp. 15–6; and Suppliers, pp. 124–5), but it depends on the machine being used. Companies such as Flow, OMAX and other water-jet manufacturers produce their own software for their machines.

If you are used to controlling the cutting of your work from start to finish, this is the one area that you will probably have to hand over to another person. If you are using a machining company, you will not be able to operate the machine yourself. The main consideration for you will be to get the initial drawing correct and achieve a good level of communication between yourself and the machine operator. If you want to get an insight into the program, you can obtain trial packages of different software on the Internet.

Procedure for using the water-jet

The sequence of events that takes place when using a water-jet machine is explained here.

1. **Drawing:** Create an electronic file for the design. For example, the design for the work *Crackerjack* (see opposite) was drawn directly in the water-jet machine software, which is sometimes easier in the case of simple geometric forms.

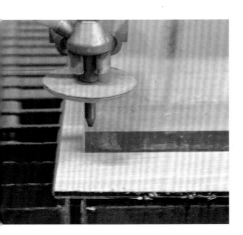
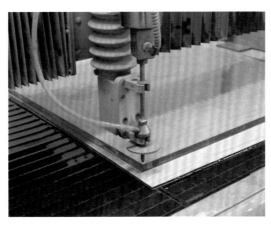

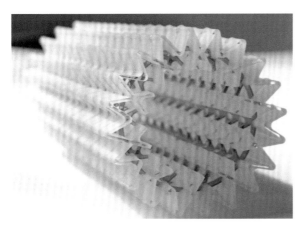

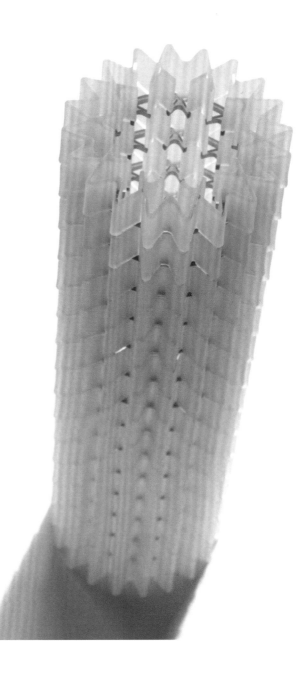

The manufacture of *Crackerjack* by Vanessa Cutler, 2011. These photos demonstrate the set-up and cutting of 19 mm glass, dimensions of final form 11 x 11 x 33 cm (4½ x 4½ x 13 in.). The first photo (top left) shows the glass resting on plywood on the machine, while the second (top centre) gives a longer view of the glass on the machine. The next photos (top right and centre left) show the cutting of the shape with abrasive garnet – the pink is the garnet residue) and the next (above) is a profile shot of the glass stacked and bonded together. The final photo (right) is the completed piece. *Photos: courtesy of Vanessa Cutler.*

Programming in Lantek for the nesting and machining of Esther Adesigbin's *I am fine* (see p. 43) using the water-jet. Often when a piece is so fluid and large, it has to be programmed into the machine in sections, as the amount of CNC code might otherwise be too much for the machine's memory.

Photo: courtesy of Vanessa Cutler.

Otherwise, you would draw in CAD software and export a vector file. When working in multiples, only one shape has to be drawn to the correct dimensions. This can then be nested and multiplied into a specified size of glass sheet. A CNC code is generated in software such as IGEMS for the machine.

2. **Position the glass:** Place the glass on the machine with plywood resting underneath; this stops any residual blasting or damage to the underside of the glass. At this stage, weight down the glass if required: see below about quality of cut.

3. **Zero the cutting head:** Set the nozzle of the water-jet at zero coordinates for the x-, y- and z-axis at the lower left-hand bottom corner of the glass: cutting will start from this point.

4. **Program:** Input the CNC code from the computer into the memory database of the machine and start the program.

5. **Piercing:** The program will first pierce all the start points in the glass, known as 'pierce points'. The cutting of glass requires different considerations to those of metal. As it is a brittle material, the initial piercing has to be done at a low pump pressure (usually 11,000–18,000 pounds per square inch, or psi). If you are cutting a shape from the edge of the glass, low-pressure piercing is not required.

6. **Cutting:** Once all the piercing has been completed, the pressure can be increased to start cutting. Cutting pressure is 52,000–65,000 psi. It is best to program the machine to cut from the lower left-hand side of the glass across to the top right-hand corner. This is so the nozzle doesn't pass over any loose glass that it may knock, causing the glass to move or, worse still, to unseat a small piece that could possibly cause the glass to fracture.

7. **Finishing:** Once cutting is complete, hose down the glass and lift it from the machine. Then wash and dry the machine to remove any residue left after cutting or from the support material.

Sample cut

Before committing to having something cut, get a sample. When I am producing work for other artists, I always do a sample first to make sure it is what the client has envisaged. It also gives me the opportunity to check that the files have not corrupted or the scale altered (on some occasions, the transfer from JPG to vector file can alter the scale and dimensions). The sample gives you the chance to talk further about alterations and finalise the cost of cutting.

Quality of cut

When having work cut, you need to consider the quality of the cut. If cutting 20 mm (¾ in.) glass, especially a large sheet, the glass does not need to be weighted down. However, if cutting thinner glass such as 3 mm (¹⁄₁₀ in.) float glass, or even Bullseye glass, this would need to be weighted around the edge. Depending on the complexity of cut, the support material underneath may need to be thicker.

Also consider that different types of glass are harder than others and some are quite brittle. If glass has been fused often, it has more strength, but if it has not been annealed properly, flaws or fractures can occur during cutting.

A water-jet machine can cut at 2,000 mm (78¾ in.) per minute in a straight line, but the cutting may not be of good quality at that speed – cutting too fast could induce fractures in the glass later.

When discussing a project with a company, you may wish to suggest that glass under 6 mm (¼ in.) thick should be cut according to the parameters for 6 mm glass. This allows the machine to operate more slowly and should help keep the quality of work high, especially if you are not able to get material cut with the suggested mesh size (see p. 52 for information about milling and mesh sizes).

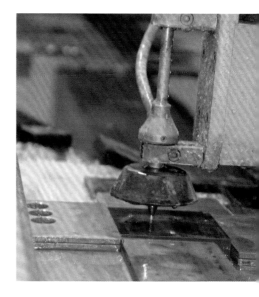

A water-jet machine cutting glass with garnet abrasive.
Photo: Vanessa Cutler.

VANESSA CUTLER: MY OWN METHODOLOGY

Over the last ten years, the water-jet has been my primary method of production. I have combined it with a variety of processes in the creation of kiln-formed and hot-worked glass artworks, challenging the parameters of the machine and the material. I have helped other artists to apply the process to their own work and gained a hands-on understanding of the application of machining to the traditional skills of creative glass manufacture. Having the opportunity to develop, program, cut and manufacture has brought about a whole new understanding for me of the intimate relationship between art and engineering.

It is the water-jet's ability to cut multiple shapes accurately and much more quickly than cutting by hand that has influenced my work. The quality and finish of cutting is very important in the end result; understanding the different results achieved by cutting with different grades of mesh has helped the work to develop. The shapes that I create are drawn directly in the water-jet's software, which reduces any excess programming. However, I realise that I will need to acquire further software knowledge if the work is to progress, especially if I wish to incorporate other technologies.

BELOW LEFT AND RIGHT Cutting delicate shapes in Bullseye glass with water-jet. *Photos: Vanessa Cutler.*

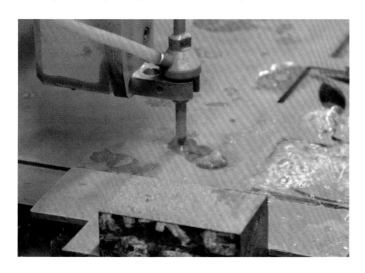

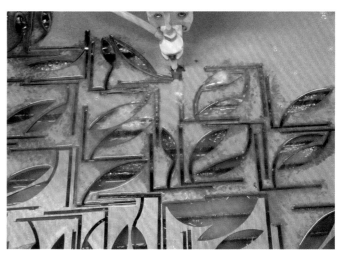

ABOVE AND RIGHT **Vanessa Cutler,**
Intertwine, 2010. Glass cut by water-
jet and bonded, 18 x 18 x 40 cm(7 x 7
x 15¾ in.). *Photo: Simon Bruntnell.*

The machine's ability to cut glass from 1–300 mm (¹/₂₀–12 in.) thick allows me to incorporate various thicknesses of glass into my work. For example, in *Intertwine* and *Transformer*, sections of glass were bonded together: no heat or further treatments were applied. My aim was to avoid applying any further cold processes to the cut surface that would detract from the quality of finish that can be produced using the water-jet machine.

Much of my work is challenging the parameters of the machine in terms of cutting speeds, abrasive flow, the codes used and piercing times and determining what effect the machine might have on the material. From an investigation into how glass reacts to the pressure of being pierced, a small part of the process has developed into the generation of a new aesthetic for me and resulted in the artwork series *Partial Piercings* (opposite).

For this series, instead of creating holes, the process was closely controlled to abrade the glass without going through it, creating abraded channels. The water-jet did not travel across the surface of the glass but was held stationary to penetrate deep into its surface, the depth controlled by an understanding of timing and the amount of abrasive in the jet. It was also important to understand the properties of the glass, as the risk of fracture during the process was high – the deeper the piercing, the higher the risk. However, taking those risks is part of my methodology.

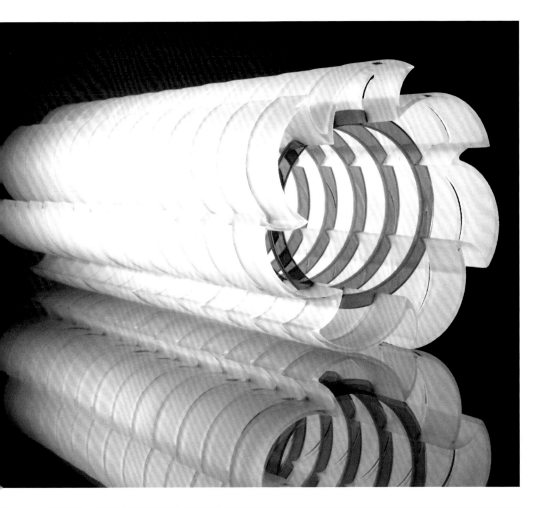

Vanessa Cutler, *Transformer #1*, 2010. Cut by water-jet and bonded, 11 x 11.5 x 34 cm (4½ x 4¾ x 13½ in.). *Photo: Simon Bruntnell.*

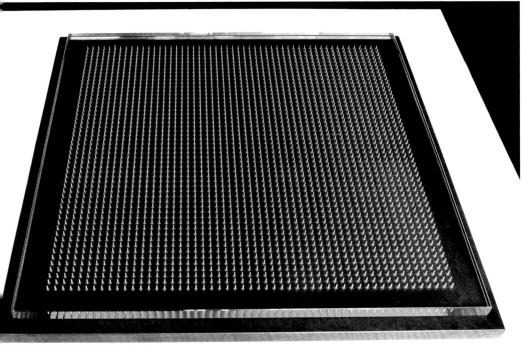

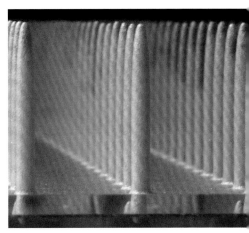

ABOVE Vanessa Cutler, *P1 Partial Piercing*, 2006 (detail). Side profile in 19 mm soda-lime glass. *Photo: David Williams.*

LEFT Vanessa Cutler, *P1 Partial Piercing*, 2006. Partially pierced glass, 60 x 60 x 2 cm (23⅝ x 23⅝ x ¾ in.). *Photo: David Williams.*

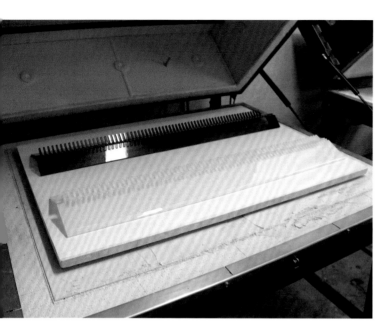

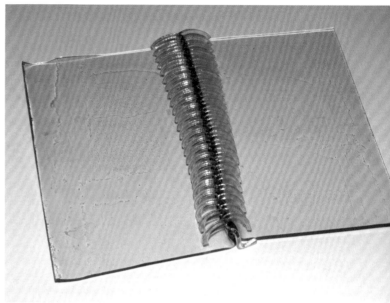

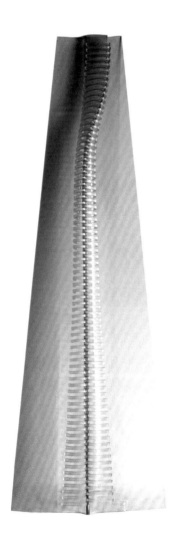

ABOVE LEFT Set-up in the kiln and one outcome. Zipped glass is cut by the water-jet into two comb-like shapes. They are placed in the kiln and interlocked together. They are not supported by anything else, only by the two pieces of glass themselves, before the kiln is closed. The glass fuses at a certain temperature and slumps under its own weight. *Photo: Vanessa Cutler.*

ABOVE RIGHT The first happy accident in the *Spinal* series, which is based on cutting combs. Combs are a result of cutting a castellation in two pieces of glass and locking them together. *Photo: Vanessa Cutler.*

LEFT Vanessa Cutler, *Spinal Wave*, 2006. Cut by water-jet and slumped, 180 x 70 x 8 cm (71 x 27½ x 3¼ in.). *Photo: David Williams.*

SPINAL SERIES

In my continuing *Spinal* series of work, the water-jet enables me to cut shapes which could not be cut by other means. These are then placed in the kiln. Water-jet technology and the traditional techniques of kiln-forming, such as fusing and slumping, are combined to create another type of work where the accuracy of the machine is allied with the unknown when the work is placed in the kiln. The way that the work is set up in the kiln is important, as is the thickness of the glass, the thickness of the combs being cut and the temperature of the kiln. The combs interlock in the kiln and are held by their own weight; no props or additional kiln furniture are added. The results are unpredictable and have been dramatic, as seen in *Spinal Wave* (left).

Other artists using the water-jet machine

Other artists who have used water-jet cutting technology in their work include Esther Adesigbin (UK), Alexander Beleschenko (UK), Thierry Bontridder (BEL), Jon Chapman (USA), Scott Chaseling (AUS) Eric Hilton (UK, based in USA), Jeffrey Sarmiento (UK), Inge Panneels (BEL, based in UK) and Brian Boldon (USA). The work of some of these artists is described over the following pages.

LEFT Jon Chapman, *Monotonous Ware, MW. No. 927277*, 2010. Motor, water-jet-cut glass, laser-cut steel, steel, 35.5 x 106.5 x 1.5 cm (14 x 42 x ⅝ in.). *Photo: ETC Photo, Rochester, NY.*

BELOW Brian Boldon, *Liquid Gunlocke*, 2007. Boldon applies digital printing in his work as well as traditional glass techniques such as slumping and fusing. He, like Jonathan Chapman, also makes installation-based works that utilise light, sound and other materials alongside the glass. Installation in a 6 x 6 m (20 x 20 ft) area, water-jet-cut glass pieces 127–183 cm (50–72 in.) long. *Photo: Amy Baur.*

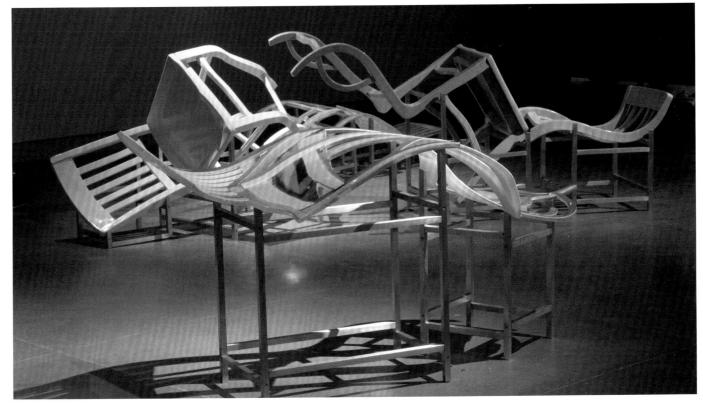

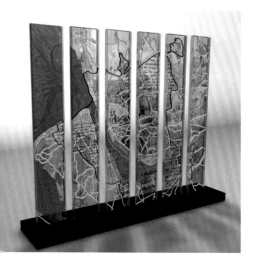

JEFFREY SARMIENTO AND INGE PANNEELS

These two artists use water-jet technology to great effect. The *Liverpool Map* (2010) is a great example of combining the technology with techniques such as screen-printing and kiln-forming. The piece builds images on multiple layers. Complex forms were cut, slotted together and fused so that they became single sheets of glass again. Multiple layers of glass were then cast and polished. The water-jet was ideal for mapping and generating negative and positive spaces, using coloured glass with interlocking screen-printed areas of glass and enabled a complex design to be created without the unevenness that would result from having to layer irregular coloured shapes.

This process of interlocking different shapes together is a technique known as 'jigsaw-fitting'. By cutting the internal shapes out, another part can be programmed and cut to fit into the space without distortion when it is placed in the kiln. Usually, when cutting out a shape, you have to allow for a small linear gap between the glass being cut out and the glass that will be left over. To fit a piece of glass into that shape perfectly, like a jigsaw piece, the internal form has to be cut slightly bigger. This is

TOP Inge Panneels and Jeffrey Sarmiento's initial design for the *Liverpool Map*. *Photo: CAD rendering by Bettina Nissen.*

ABOVE Jeffrey Sarmiento showing a glass sample of the complex water-jet-cut imagery to be inserted into the layers of glass. *Photo: Inge Panneels and Jeffrey Sarmiento.*

RIGHT Inge Panneels and Jeffrey Sarmiento, *Liverpool Map*, 2010. The work consists of six columns, each weighing 100 kg (220 lbs) and containing 17 layers of glass, 225 x 33 x 5 cm (88½ x 13 x 2 in.). Held at Museum of Liverpool. *Photo: Simon Bruntnell.*

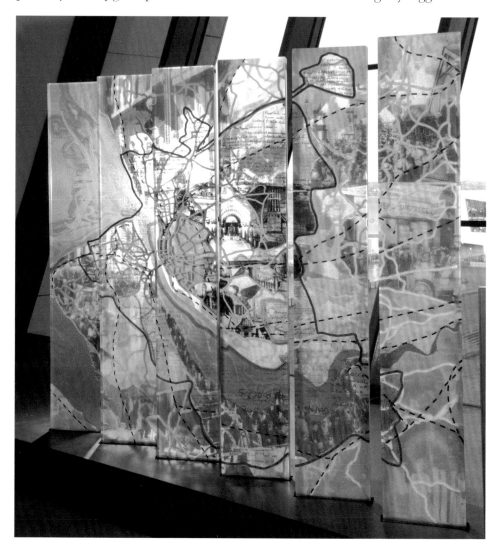

known as allowing for the 'offset': when you know the amount of offset needed, the glass can be slotted together; if you don't allow for the offset, the shape will be slightly smaller than it needs to be and will not fuse evenly to give a perfect join. The accuracy of water-jet cutting means that this process is much easier than it has been in the past.

Both artists have used the water-jet in work carried out individually for commissions and exhibitions. Inge has used fine cutting to insert and slot delicate shapes into casting and to fuse shapes back into single sheets. Her *Macro Micro* series shows the intricate cutting fused back together (above); *Smile* demonstrates the use of a simple image cast into another colour of glass without distortion. The cutting by water-jet enables the fusing to remain sharp and the imagery to retain its detail and complexity.

In his own work, Jeffrey has used the water-jet for jigsaw-fitting in a similar manner. He combines the water-jet machine with a multitude of other techniques and views it as another tool in his arsenal of processes to create work. His work exemplifies how the process can be used to create a softness of form, while still retaining sharpness (below). Jeffrey's wall-mounted panels and objects are held in collections in the UK and USA.

ABOVE LEFT AND RIGHT Inge Panneels, *Macro Micro*, 2010. Water-jet-cut and fused Bullseye glass, diameter 28 cm (11 in.). *Photo: Kevin Greenfield.*

In these works, Inge has used mapping and topography of the terrain as inspiration. She was interested in the delicacy of cutting that the machine can achieve, jigsaw-fitting pieces together and casting them into one form. The works demonstrate how fine and precise the cutting has to be in order to slot together without air bubbles and gaps.

BELOW Jeffrey Sarmiento, *Occupation*, 2008. Water-jet-cut and fused glass, 108 x 53 x 4 cm (42½ x 21 x 1½ in.). *Photo: David Williams.*

Jeffrey Sarmiento, *Comb*, 2010. Printed, water-jet-cut glass, fused and carved, 15 x 8 x 1 cm (6 x 3¼ x ⅜ in.). *Photo: David Williams.*

One of the differences between the two artists is that Jeffrey is able to operate the water-jet machine himself and is more aware of the capabilities of CAD/CAM software, using both Illustrator and RhinoCAD. Inge does not use the water-jet directly. The *Liverpool Map* was an opportunity for the two artists to pool their knowledge, generating a large-scale casting project and demonstrating how the technology has been incorporated sympathetically into two people's methodologies.

ESTHER ADESIGBIN

Esther Adesigbin has used the water-jet to help her realise her work. The use of text, handwriting and scribbles in glass artworks, as in Esther's work, can prove difficult without a water-jet machine. It can be done by sandblasting, but the water-jet is faster and more economical. Sandblasting produces a rougher, irregular glass edge. The water-jet produces an abraded edge, but it is straighter and much more accurate.

Handwritten words are not the easiest outlines to produce in CAD software, but by scanning in her handwriting and scaling it to size, then tidying all the shapes in Illustrator, she achieves the results she requires. Management of the files is very important for her, as is capturing the fluidity of form in handwriting without it looking vectored.

The file sizes are particularly difficult, because the number of vector points in each file is enormous. This presents a problem, because having too many lines in the vector file can confuse the machine – and when the machine becomes confused, it tends to just cut a circle. The initial drawings are very fluid, making the vectors even more complex. In some instances, she has found that files can't be opened on the machine and any alteration in the file takes several minutes to apply.

Going from handwritten text on paper to fluid, handwritten shapes cut in glass is quite a transition and one to which the water-jet process is ideally suited. Esther has also looked to slump complex forms after cutting and found that, while cutting was achievable, handling was difficult. Attention to the thickness of glass chosen and the thickness of the support material used for cutting made this more manageable.

Although Esther does not cut the work directly, she works extremely closely with the technician in order to gain an understanding of the process and use that

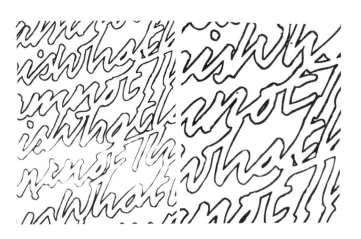

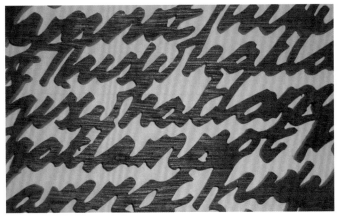

These photos demonstrate the development of Adesigbin's ideas; instead of laborious sandblasting, she eventually opted for a water-jet.

ABOVE LEFT Esther Adesigbin's initial drawing ideas for *I am fine*. *Photo: Esther Adesigbin.*

BELOW LEFT Scan of initial sample, achieved by sandblasting, for scribbled mirror. *Photo: Esther Adesigbin.*

ABOVE RIGHT The plywood support left behind after the glass had been cut. It demonstrates how the technology is able to cut the lettering so close to the original design. *Photo: Vanessa Cutler.*

BELOW RIGHT Esther Adesigbin, *I am fine*, 2008. Water-jet-cut, slumped and gilded glass. Note how similar the initial handwritten text is to the final outcome in glass, 180 x 50 x 20 cm (71 x 19¾ x 8 in.). *Photo: Esther Adesigbin.*

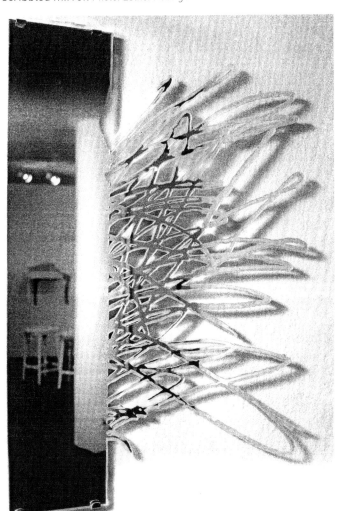

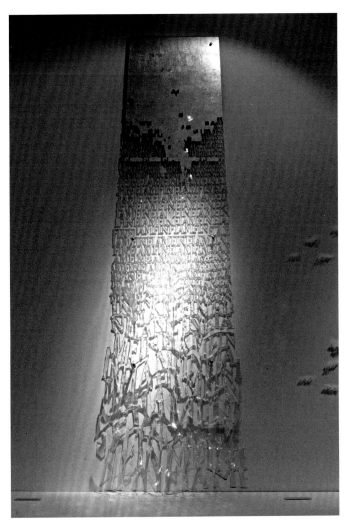

knowledge in future work, learning to adapt designs to add strength or to work with different techniques alongside it. She confidently applies the process to her ideas. Water-jet cutting technology has made the production of her work more achievable.

Water-jet technology and other glass processes

The water-jet process has been used in many glass techniques, from applying shape to a vessel to casting water-jet-cut shapes into sculptural forms. Artists Rena Holford and Rachel Elliott have used kiln-forming techniques such as casting, fusing and slumping, combining this with traditional architectural glass processes such as screen-printing, glass painting and the use of silver stain. Rena uses paint techniques alongside the cutting to add texture and colour to the surface and Rachel has used screen-printing on the surface. Both work on similar themes, but with a very different aesthetic and in a variety of scales. More on hot-worked and kiln-formed glass follows on p. 47.

Rena has produced large-scale horses for the last four years, often broken into sections to fit the bed of the water-jet machine, the size of glass available and the size of the kiln.

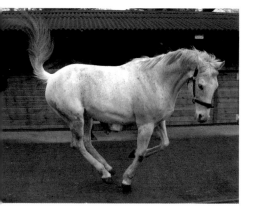

BELOW Silver, who inspired the work, pictured at Hagg Hill Farm in 2008. *Photo: Rena Holford.*

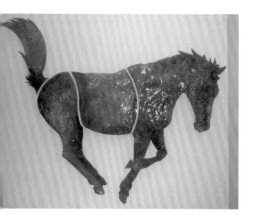

ABOVE Rena Holford, 2008. The horse was made by water-jet-cutting glass and slumping in a kiln over sand, with a mix of silver stain and glass paints. Exhibited at the National Glass Centre, Sunderland, 330 x 220 cm (130 x 86½ in.). *Photo: Rena Holford.*

RIGHT Rena Holford, 2008. Water-jet-cut glass, silver stain, paint and embossing. Installed by the National Trust at Bamburgh Castle, Northumberland, 300 x 220 cm (118 x 86½ in.). *Photo: Rena Holford.*

Rachel Elliot, *Glare*, 2011. Glass with screen-printing and enamels, 175 x 95 x 1 cm (69 x 37½ x ⅜ in.). *Photo: courtesy of Perth Museum and Art Gallery, Paul Adair.*

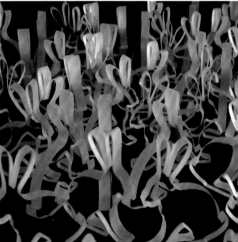

Rachel Elliot, *Leverets*, 2011. Multiple cut glass forms, 7 x 10 x 1 cm (2¾ x 4 x ⅜ in.). *Photo: Rachel Elliott.*

Rachel's *Glare* is cut from one sheet of glass, screen-printed with enamels. Alongside this, she has produced a whole series of leverets to help fund the larger *Glare* project. She has built a good relationship with a local company that cuts the glass for her and is now willing to experiment a little more with her ideas. She has applied small, screen-printed images on limited runs such as *Leverets* (multiples of hares, plain version of which is as shown on right) and is able to sell these at a cost-effective rate.

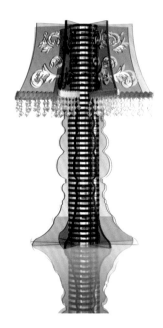

ABOVE Margareth Troli, *Bar (Roch)ococo Lamp*, 2010. Fused, water-jet-cut glass, 53 x 35 cm (21 x 13¾ in.). Held at Broadfield House Glass Museum.
Photo: Simon Bruntnell.

ABOVE RIGHT Setting the cut glass: this is an example of how the water-jet can cut the variety of materials needed for formers and the glass to produce work like *Raised Crossing*. The kiln set-up shows developmental work for a similar work called *Three Layers*.
Photo: Vanessa Cutler.

CENTRE Vanessa Cutler, *Raised Crossing*, 2006. This sort of outcome can be produced using the kiln set-up shown top right, 20 x 20 x 4 cm (8 x 8 x 1½ in.). Held in a private collection.
Photo: David Williams.

RIGHT Erin Dickson, *Tumbler*, 2009. Erin's *Tumblers* are manufactured using water-jet machining. By cutting the glass into sections, she is able to create 2D layers of glass which can be reassembled into the tumblers, 15 x 7 x 7 cm (6 x 2¾ x 2¾ in.).
Photo: David Williams.

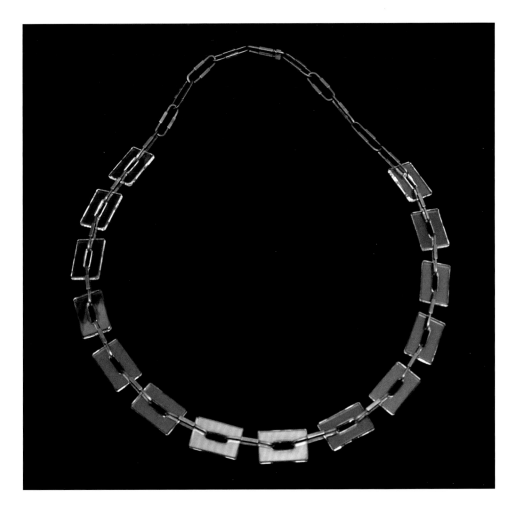

LEFT Blanche Tilden, *Brunel*, 2010. Each glass component in the necklace was drawn in CAD software, cut by water-jet out of 3.3 mm-thick borosilicate sheet glass, then hand-ground, finished and flame-worked by Blanche. Water-jet-cut and flameworked borosilicate glass, oxidised 925 silver, 1.2 x 27 cm (½ x 10⅝ in.). *Photo: Marcus Scholz.*

BELOW New developmental research into the use of residual plywood from the water-jet-cutting of glass forms to produce moulds. Here, the leftover, cut plywood shapes have been layered and glued together to make a former. The former is surrounded by plaster, placed in a kiln, and what is left is a space to fill with glass frits. The outcome is a core with a different texture than is usually created by a water-jet. *Photo: Vanessa Cutler.*

BOTTOM The 'burn-out plywood process' for mould-making, as described above. *Photo: Vanessa Cutler.*

WATER-JET CUTTING FOR MOULD-MAKING

Artists such as Margareth Troli (opposite) have explored the use of the water jet to cut mould materials – from polystyrene to wood, foam board, wax and steel. Leftover plywood can be recycled into moulds too, as described in the caption on the right. The water-jet is very effective for creating multiple shapes and cutting through variable thicknesses and artists continue to investigate its potential. The images on p. 46 demonstrate Margareth's work with kiln-forming techniques, as well as showing how glass can be slumped through water-jet-cut moulds or formers.

WATER-JET CUTTING WITH HOT-WORKED AND KILN-FORMED GLASS

Many artists creating hot-worked glass and kiln-formed glass have added the use of water-jet machines to their repertoire in the last five years, as the technology has become available through various educational institutions and commercial enterprises.

Hot-worked glass is created using a glory hole and furnace, and tools such as blowing irons, to free-form blown objects in glass. Kiln-formed glass is created using moulds, and techniques such as fusing and slumping, to generate sculptural

RIGHT Jacqueline Cooley, *Bowl*, 2009. Cut with water-jet, fused and slumped, 50 x 50 x 10 cm (19¾ x 19¾ x 4 in.). Held at Broadfield House Glass Museum. *Photo: Simon Bruntnell.*

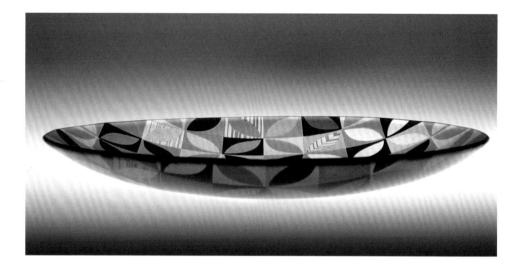

forms and objects. Using water-jet machines, artists working in these ways can cut singular and multiple forms in various thicknesses of glass and then fuse or cast them together. The *Liverpool Map* (see p. 40) is one such example. Wendy Ramshaw, Elias Bohumil, Shelley Doolan and Margareth Troli all work in this way.

Thierry Bontridder, a Belgian artist, uses a local company called Water Cutting in Gembloux. His pieces are cast and slumped, then cut and shaped in the kiln to create dynamic forms that seem to take flight. In several of his pieces, he has cast shapes into the forms as well as cutting the external shape. In some instances, the forms fit together like a jigsaw, demonstrating the accuracy of the cutting (for example, *Gris*, opposite). French artist Fabien Moudileno, who trained at CERFAV, and Jacqueline Cooley, who is based in the UK, have used a water-jet for fusing and slumping, allowing them to retain accuracy in interlocking shapes and so weave complex patterns. Jacqueline has used the Creative Industries Research and Innovation Centre (CIRIC) to cut her forms, along with companies close to her studio in the West Midlands. Both have learnt to generate shapes in the formats that the companies work with.

Aside from kiln-forming, there is a lot of potential for the water-jet in hot-worked glass. The Australian artist Scott Chaseling has used the process to create murrine. To make his ducks (left), he fused three blocks of coloured glass measuring approximately 5 x 10 x 10 cm (2 x 2 x 4 in.). He cut the separate shapes of the duck, its beak and eye out of the glass and then slotted them into the opposite colours. For the eye, he placed a black rod cane in a pierced hole made in the glass by the water-jet. The blocks were recast, picked up and made into cane, producing three different coloured ducks. Scott was able to apply the process imaginatively and it enabled him to maximise the glass he had.

The use of the water-jet in hot-worked glass involves multiple processes. Sometimes, water-jet-cut shapes can be added to a blown-glass form when it is hot. They can be melted into the form or added to the surface and left as a raised image. The water-jet can also be used to cut or trim an object afterwards. After it has been through a kiln process, the work may sometimes spread or deform, and the water jet can be used to make alterations, but this is dependent on the form of the object. There is a lot of scope for artists to take the process further.

Scott Chaseling, *Ducks*, 2008. Glass murrine, 1 x 1 x 0.3 cm (⅜ x ⅜ x ⅛ in.). *Photo: Vanessa Cutler.*

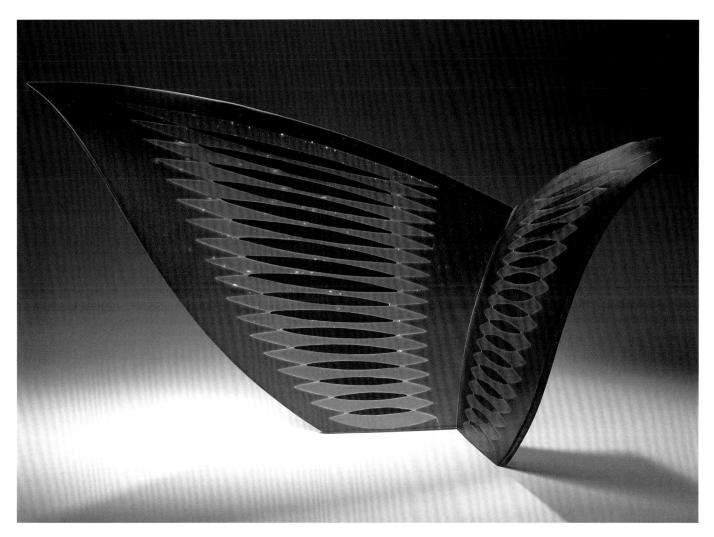

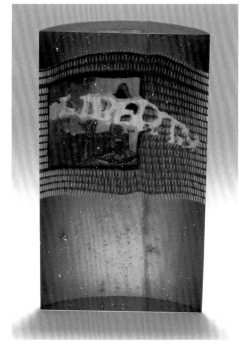

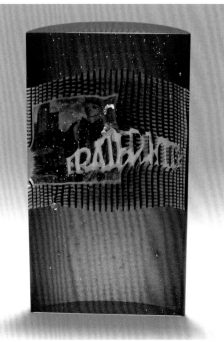

ABOVE Thierry Bontridder, *Gris*, 2004. Glass, 49 x 73 x 55 cm (19½ x 28¾ x 21½ in.). *Photo: Paul Louis.*

LEFT Scott Chaseling, *Songs from afar*, 2008. Painted, fused, water-jet-cut and cast glass, 53 x 23 x 16 cm (21 x 9 x 6¼ in.). *Photo: Terry Davidson.*

RIGHT Scott Chaseling, *Fraternity*, 2008. Painted, fused, water-jet-cut and cast glass, 53 x 23 x 16 cm (21 x 9 x 6¼ in.). *Photo: Terry Davidson.*

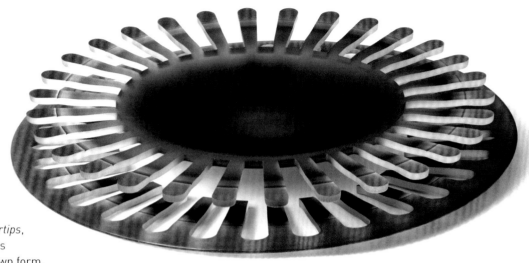

RIGHT Vanessa Cutler, *Fingertips*, 2009. Glass blown by James Maskrey. Water-jet-cut blown form, 50 x 50 x 7 cm (19¾ x 19¾ x 2¾ in.). Held in a private collection, USA.
Photo: David Williams.

BELOW Vanessa Cutler, *Backbone*, 2008. Water-jet applied to hot-worked glass; blown glass and water-jet-cut, kiln-formed spine, approx. 30 x 12 x 12 cm (12 x 4¾ x 4¾ in.). Held in the American Museum of Glass, Wheaton, USA.
Photo: Vanessa Cutler.

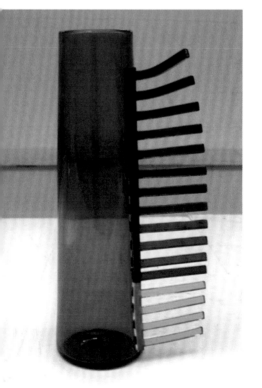

Scott Chaseling has used the water-jet to cut kiln shelves in order to help dam work in the kiln and also to maximise the cutting of glass strips out of a sheet of fused 9 mm (⅓ in.) glass, as well as glass murrine. He has also used the process to patchwork/jigsaw-fit shapes together while they are hot.

The photos here demonstrate how the water-jet machine can be applied in several ways, from the making of murrine and large glass tiles with water-jet wording inserted and fused down, to lettering applied afterwards as an additional element, as seen in *Fraternity* (p. 49). The figure on the left shows water-jet-cut shapes appliquéd to the hot surface of the glass with much distortion. James Maskrey and I have explored how to apply hot water-jet-cut shapes to the body of a form (known a hot appliqué), creating distortion. This is something that has the potential to be explored further. Most artists creating hot-worked and kiln-formed glass know that the colour and thickness of glass affects its ability to stretch and distort, especially with complex water-jet-cut forms. I'm looking forward to seeing the outcome of experimentation in this area.

Surface abrasion

Another process achieved with the water-jet is that of milling or surface abrasion (milling can also be known as pocketing – the ability to produce pockets of abraded material in the surface), where a jet of water skips across the surface of the glass at low pressure to abrade it.

Water-jets can carry out surface abrasion, but this is not always a total success when working in glass. Water-jet manufacturers such as OMAX have produced software that works purely in relation to surface milling. On materials such as steel and aluminium, surface abrasion is much easier to control. An abraded metal component could always become the mould for a glass piece. Abrasion and mould-

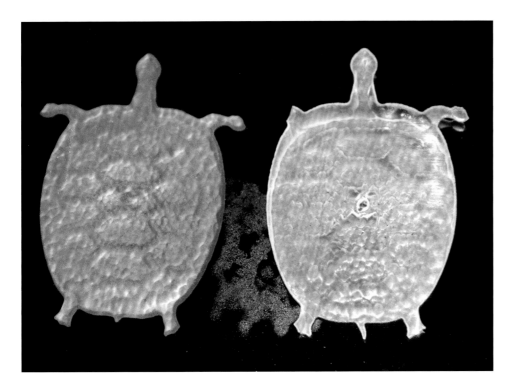

Demonstration example by Nate Weber of OMAX, 2011. This water-jet-milled glass tile turtle is an example of a form that has been surface-abraded using the OMAX water-jet. Using the OMAX machine's program, the entire surface of the glass is abraded at once. However, the machine is following a tool path that will vary its speed within a single path. The speed of this path determines the depth of abrasion, 5 x 4 x 0.5 cm (2 x 1½ x ¼ in.). *Photo: Vanessa Cutler.*

Vanessa Cutler, 2006. An example of surface abrasion on turquoise flashed glass, 20 x 20 x 1 cm (8 x 8 x ⅜ in.). *Photo: Vanessa Cutler.*

building with material such as metal, graphite and even wood has much potential in creative glass practice.

On glass, the shape and evenness of abrasion can be controlled up to a depth of approximately 6 mm (¼ in.); if you intend to make complex forms, it may be better to use a sandblaster. The deeper the nozzle that makes the abrasion, the more the taper of the shape increases. A metal mask is used to protect the surrounding surface of the material. The distance of the nozzle from the material is a factor in

achieving the desired evenness, as is the pressure used to abrade. Abrasion is done at a low-pressure setting (4,000–18,000 psi), which is much less than the cutting pressure of 55,000–63,000 psi.

The water-jet will pass over the surface quickly so that it does not create troughs in the glass; the idea is to create a U-shaped channel rather than a V-shaped groove. By overlapping the cut, varying the speed and monitoring the abrasive flow of the jet, the finish produced on the surface can vary. The more distance between the lines, the coarser the surface becomes. The size of the garnet mesh can also affect the finish. By using a fine nozzle, such as a 0.5 mm, and a 220-mesh or finer, you can produce delicate designs; however, they are not etched very deeply into the surface.

There are currently two methods of abrading materials: the first is to use a steel stencil to mask areas that you do not want to abrade, the second is to use software that scans in the image you require. Areas of shading and definition are graded and the program decides on the speed of the nozzle as it travels across the area. Each line is made of variable speeds, depending on how the software has read the image. It is a method that works well for metal, but it is not as effective on glass.

For glass, my recommendation would be to do the pocketing/milling using a steel stencil to make a design. Alternatively, you can use the software program to create the image in a different, harder material and then use that for a glass mould rather than direct embellishment on the glass surface. However, the software is useful for surface abrasion and for part numbering (that is, numbering the shapes that are being cut). A combination of the two is something that could be explored further.

Water-jet cutting in architecture

For architectural commissions, machining and industrial processes play a large role. Studios that specialise in architectural glass, such as Franz Mayer of Munich and Savoy Studios, Portland, USA, have their own water-jet machines to aid in the manufacture of large-scale work. Other glass studios contract external companies to help them: Derix Glass Studios, London Glassblowing and Andrew Moor Associates have all used water-jet machining companies to realise architectural commissions.

In the USA, companies such as Creative Edge Master Shop have been working with artists and architects for many years. This company has developed a wide knowledge about cutting a variety of materials. Artists who make stone and metal sculptures and designers producing corporate signage and floor inlays have relied on its expertise. It has been particularly popular in the production of stained glass and for cutting glass trophies.

The advantages of using the water-jet for architectural commissions include reduced material wastage and the ability to cut within a tight timescale. Complex shapes can be cut effectively and it is easy to produce multiple shapes – ideal if the requirement is for 500 of one shape in various colours, which all need to fit and match exactly.

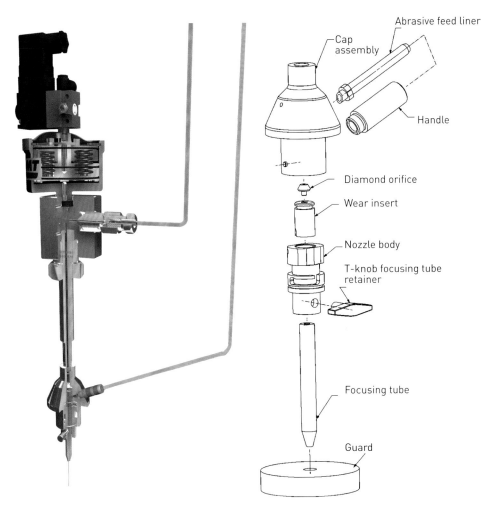

Cap assembly

Abrasive feed liner

Handle

Diamond orifice

Wear insert

Nozzle body

T-knob focusing tube retainer

Focusing tube

Guard

FAR LEFT A water-jet cutting head.
Photo: KMT Waterjet, courtesy of Pete Longman.

LEFT How the cutting head works. This figure allows you to see the way that water and abrasive are combined to create a pressurised force that is able to cut various thicknesses of glass.
Photo: KMT Waterjet.

Various materials, including foam and wax, cut with a water-jet for mould-making.
Photo: Margareth Troli.

ABOVE OMAX water-jet software, Intelli-ETCH, showing the programming for milling a trial glass sample. Size of tile 10 x 10 x 0.4 cm (4 x 4 x ¼ in.). *Photo: Vanessa Cutler.*

ABOVE RIGHT AND RIGHT Milling set-up at the head-quarters of OMAX, Seattle, USA. *Photo: Vanessa Cutler, courtesy of OMAX.*

Daniel Butler, sample piece, 2009. Glass surface milled by water-jet, milled area 9 x 9 cm (3½ x 3½ in.), depth of abraded surface 2–3 mm (¹/₁₀ in.). *Photo: courtesy of Daniel Butler.*

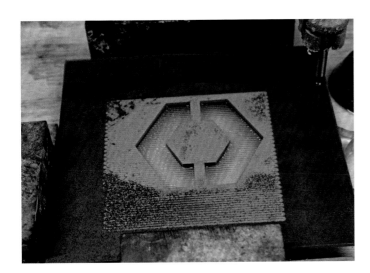

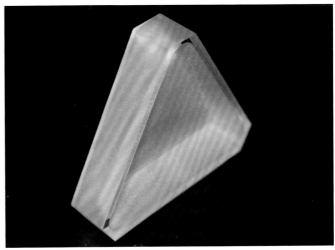

ABOVE LEFT Daniel Butler, 2010. Using a steel template to surface abrade 20 mm-thick glass. *Photo: Vanessa Cutler.*

ABOVE RIGHT The kind of outcome that can be achieved using a template to abrade a design on to a glass surface. *Photo: Vanessa Cutler, courtesy of OMAX.*

Costs

The cost of machining varies according to where you go and the type of work you need done. There is normally an initial set-up cost, relating to how much programming is required. The more you prepare, the less the machining company needs to do; in some instances, companies may do a trial sample before undertaking a large job.

The cost of cutting time can be anything from £80–150 an hour, when you supply the material to be cut. Some companies might purchase the material for you, but usually, if it is glass, they prefer you to supply it. The price of cutting may seem expensive, but if you are cutting multiple shapes, the time savings and the accuracy of the parts produced is likely to make it cost-effective (especially if you wish to cut complex forms out of a sheet of glass; if done manually or by other automated processes there is a limit in terms of the complexity of form that can be achieved). The thicker the material, the longer the cutting time. Also, the more fragile the shape, the more risk there is of it breaking.

Surface abrasion is a standard service provided by water-jet companies for etching, marking and pocketing steel, but there may be only a few companies willing to experiment with glass. The costs would be expensive as downtime and wastage are high. Personally, I would look to other processes such as sandblasting or laser-etching, as they may be more cost-effective. However, if you want a slightly coarser effect, you may wish to experiment with water-jet abrasion. Cost-wise, it will all be negotiable with the company you talk to and the budget you have available.

3

Laser cutting and engraving

Prior to the development of laser-cutting technology, manual methods have been used for cutting glass, both commercially and within the studio. Diamonds have been used to cut glass since the Renaissance and are still used today in the form of diamond-sintered tools. Carbide wheels, the descendants of a medieval ball and grozing tool, are also used; they are attached to a handle and run over a glass surface to score it, before grozing tools break away the desired shapes.

The main difference between the cut of a laser and that of a manual break is that the former produces a straight edge that would not cut or damage skin if a finger was run across its edge. With the development of laser-cutting technology and techniques, artists are able to make complex cuts in glass more cleanly, easily and accurately than by using manual techniques. Cutting glass with a laser also minimises the risk of scratching.

My first encounter with the use of a laser for glass-cutting was in the late 1990s, when I visited the laser laboratory at Loughborough University. Loughborough had established the Millennium Laser and associated processes for cutting materials and they had the ability to cut glass. Their CO_2 (carbon dioxide) laser was used with a coolant and produced a fantastic finish; however, cutting shapes other than straight lines proved difficult. The helpful staff attempted to cut float glass with the laser, without any coolant. The results were not great but demonstrated the potential for cutting circles, squares and ovals.

Lasers have progressed and now offer a variety of possibilities to glass artists, from cutting to engraving. Laser-cut material has an accuracy and finish quite different to that of water-jet and manual cutting processes.

How does a laser work?

Lasers are being used to cut glass commercially because they have a precision that is unrivalled by other processes and are very good at cutting extremely thin glass requiring tight tolerances (some glass has to meet specific tolerances if its final

LEFT Laser set-up at Vitrics.
Photo: courtesy of Jeremy Buckland, Vitrics.

BELOW Close-up of sub-surface laser machine at Vitrics. *Photo: courtesy of Jeremy Buckland, Vitrics.*

application is within optical equipment or even space instruments). There are two types of laser: 'green' and 'red', each with its own properties. A green laser gives high definition, a small point size and a fast burn time. A red laser has a larger point size and lower definition, making it slower. In engraving, point size, point density and burn time, along with the quantities of glass and quality of etch required, are all factors to be considered. Work produced by green laser is more expensive.

The principle of laser-cutting glass is a 'slash and melt' process. The laser initiates a flaw that travels across the surface, with a coolant running behind it to smooth the edge of the cut. All fissures and micro-flaws are eliminated, which is especially important for glass destined for use in the space or optical industries. It is known as a 'hot' process, applying a vast amount of heat on to the glass surface, unlike the water-jet, which is seen as a 'cold' process, as it does not heat or fracture the glass. The strength of the laser varies between 1,000–2,000 watts.

The finish on the edge of a laser-cut piece of glass is highly polished and smooth, totally unlike the abraded edge of a water-jet cut, or the sharp edge of glass cut by hand. This reduces the need for any further treatments. The laser most commonly used in the glass industry is a CO_2 laser.

When cutting materials that are to be combined with glass, a laser is often preferable to a water-jet cutter. However, the heat generated by the laser makes it unsuitable for organic materials such as wood (it can be used, but does burn the surface). Architects and textile artists use lasers for cutting a variety of thin materials such as veneers and silk. Lasers can be used to engrave most metals, but may cause silver to melt.

Sub-surface lasers are used for engraving the surface of glass (surface engraving) and inside the glass (sub-surface abrasion or sintering).

Laser engraver at Haven Laser.
Photo: Vanessa Cutler, courtesy of Haven Laser.

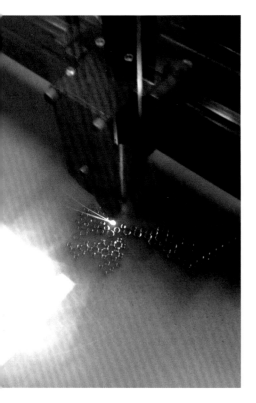

Laser-cutting a steel template for sandblasting. *Photo: Kane Cali.*

Laser cutting in glass and other materials

Laser cutting can be applied to other materials, such as veneers, paper, card, plastic and metal. When using metal, steel is preferable: aluminium and copper are more reflective and absorb the heat from the laser, making them prone to melting. Several artists have used a laser to cut their initial designs out of paper prior to manufacture and also use it to cut vinyl rather than using a vinyl plotter (see p. 110).

Lasers are ideal for cutting components, or other materials related to the glass item being produced, such as metal formers (moulds) to slump through or into. The laser gives a clean, accurate cut with a minimum kerf or taper (tapering of the cut glass edge is often created by cutting too fast) in most materials, although this does depend on the thickness of material being cut. Kane Cali, for example, has used a laser to cut steel templates for sandblasting.

Steve Royston Brown uses traditional and contemporary methods to manufacture works in clay and glass. He cuts stencils to build up glass forms prior to kiln-firing – his low-tech method of rapid prototyping. Jewellers such as Arthur Nash have used a laser to surface-engrave enamels on metal. Some artists have laser-cut Japanese paper and laminated it between pieces of glass to create backlit panels.

The following artists use laser-cutting and engraving techniques in different materials, including glass.

BATHSHEBA GROSSMAN

Bathsheba Grossman uses laser-cutting in much of her sculpture. On her very informative website (www.bathsheba.com), she offers files that can be downloaded by anyone who wishes to give laser-cutting a try. She has produced her own software to help in the manufacture of files suitable for making the complex mathematical structures she creates. Bathsheba works across technologies, but primarily in metal. She has designed lighting and other structures for sculptural and functional purposes, combining maths and technology within the works she produces.

AIMEE SONES

Aimee Sones (see also pp. 23–4) is an artist who has applied laser technology in her work. She is interesting in mapping the terrain in which she exists, whether she is visiting a place or working within it. The technology allows her to make representations of places, which give her audience a direct contact with the sites. She explains:

While I was in graduate school, I was working in the Knowlton School of Architecture's Fab Lab at OSU and began working with the laser cutter/engraver. I began experimenting with the machine and cutting/engraving various materials. After learning to engrave glass with the machine, I began rubbing Ruesche enamels into the abraded surface to accentuate the engraved lines.

LEFT AND ABOVE Aimee Sones, *Mapping Roy*, 2008. Laser-engraved kiln-formed glass. *Photo: Aimee Sones.*

While working in the Fab Lab, I was simultaneously preparing for an exhibition and planned to collaborate with my colleague Elizabeth Gerdeman to explore the gallery space the work would be exhibited in (at Roy G. Biv Gallery in Columbus, Ohio). The *Mapping Roy* piece (above) contains an impermanent graphite drawing that features the imperfections in the gallery wall, which reflect the history of the work once exhibited there. The laser-engraved glass pieces reveal the digital manipulation and translation of the floor plan of the gallery, serving as focal points within the drawing, similar to cities on a map.

KANE CALI

Kane Cali is a young designer who has an interest in using technology to produce glass objects. In the manufacture of one such piece, he used a laser to generate the 3D models from which a plaster mould could be taken, using cold-pour silicone rubber before casting with glass. He talks about his use of the process here:

Coming from a background in 3D architectural visualisation, I have always found myself fascinated by the ability to emulate reality through the use of CAD software. From a designer-maker's point of view, I find that using such a method for producing my work allows for a very fast, yet accurate sense of achievement within the creation process. It can be argued that using such a medium can restrict the creative process. However, I believe that restrictions only exist within the fluency of your ability to translate language. In this case,

ABOVE LEFT AND RIGHT These images show the progress of the digital render for the mould, which will be used to generate the form. *Photo: Kane Cali.*

RIGHT The progress of the digital render for the mould. *Photo: Kane Cali.*

the language is a digital process. The more fluent you become, the fewer the restrictions.

In saying that, this process is not without its limitations. CAD-generated objects tend to take on a synthetic appearance due to the nature of their virtual make-up. This is not to say that limitations are undesirable, for I find that working within limitations allows for a smoother workflow; in a sense, the work is directed by its limited ability to appear flawless. Possibly, the ability to be perfectly precise, in itself, is the greatest limitation. It may also be important to note that certain traits within my character, traits such as the desire for control, precision and clarity, all draw me towards using such technology.

However interesting the virtual realm may appear, I find that it lacks a certain tactile interaction that one can only truly experience through the sense of touch. During my degree at the University for the Creative Arts in Farnham, I was introduced to the marvels of a laser cutter. I can still remember the feeling of excitement as they turned the machine on, the sound of all the extractor fans, one by one being switched on, each one releasing a build-up of noise as the vacuum chambers took to life. Essentially, a laser cutter cuts along an x- and y-axis, thus producing a 2D cut-out. True to our inquisitive

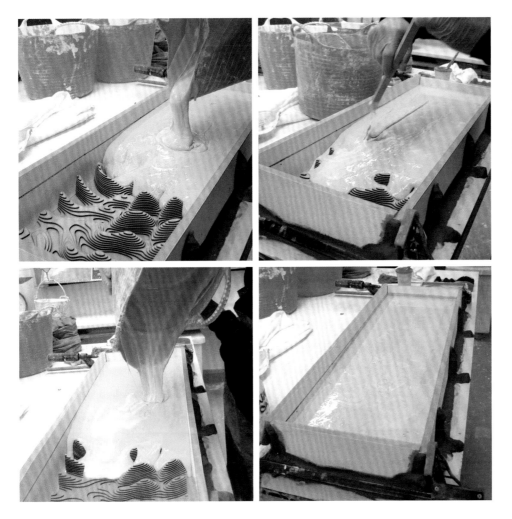

The production of the mould. The laser-cut plywood model has to be dammed to enable RTV (room-temperature vulcanising rubber) to be poured over the laser-cut wood model. This rubber mould, once set, will be the basis of a plaster mould in which glass will be cast. The images show the stages of making a rubber mould. *Photos: Kane Cali.*

human nature, we have since developed ways of using this 2D instrument to create objects that occupy the z-axis.

PRODUCING AN IMAGE FOR THE LASER CUTTER

Commercially, laser cutting works mainly by using vector-based drawings. The exact file type will depend on the machine software used to covert the drawing into CNC code. Companies may work with AI (Illustrator), DWG or DXF files, but this is also dependent on the type and age of the machine, as discussed for the water-jet cutter. Some are able to work from raster or bitmap files. As previously described (p. 10), raster files are made up of pixels, usually dealing with tone and colour, whereas a vector file is a mathematical arc – a plotted line between nodes. From the raster file, the company will generate the vector files for cutting or engraving. Note that if you do this this yourself, you are reducing the amount of work the company needs to carry out.

Others may ask for files associated with the software they use, such as point cloud files. Point clouds are focus points where the laser initiates a micro-flaw, as discussed on p. 64. The laser at Swansea Metropolitan University's Creative Industries Research and Innovation Centre reads both raster and vector files.

All companies have their own working methods and it is wise to have a detailed conversation with them before you produce an image, or visit first and see the process in action. If you follow the simple guideline of preparing a clean, sharp, single-layer drawing with no open points, it will reduce the laser company's software processing time and lower the cost to you.

Note that if you are using a photograph, you should import it into Photoshop and look at it in greyscale or black and white, because only black and white images can be used for laser-cutting.

Glass engraving/etching

Artists have been using lasers for around ten years, mainly for sub-surface abrasion (sintering) and surface engraving.

SINTERING OR SUB-SURFACE LASER ENGRAVING (SSLE)

Sintering is a process used to generate 3D forms inside a piece of glass. Artists such as Bathsheba Grossman, Geoffrey Mann, Annie Cattrell, Kirsteen Aubrey and Katharine Dowson have have applied this technique to glass blocks to produce imagery within the glass. Sintering is also used commercially for awards, trophies and keepsakes – you can send an image away to be produced in a small glass block.

Examples of sub-surface abrasion can be seen in places as diverse as souvenir shops and upmarket galleries. Vitrics, a specialist company owned by Jeremy Buckland, has the largest lasers for sub-surface laser engraving in Europe. It has undertaken work for many artists, including Annie Cattrell and Geoffrey Mann.

Engraving on polished granite memorial headstone, 2010.

Photo: Vanessa Cutler.

There are two ways of using the laser for sintering or sub-surface engraving. You can work in two dimensions by taking a drawing or photograph and using Photoshop to remove all background imagery and produce a clean, crisp image. This can be produced as a flat white image within a glass block. Alternatively, you can supply a 3D file to produce a 3D image within a glass block.

The laser company will explain what type of image and format is required to produce the effect you want. The image file required by the company, such as a vector file, will be input into the software for their laser to create a point cloud image. Once that file has been produced, the glass can be machined. If the image is taken from a photograph, the laser has only one plane on which to work and the resulting image will only be in 2D.

Types of glass for sintering

In sintering, the quality of an image within the glass can vary from crisp (sharp micro-flaws) to soft (diffused micro-flaws). A soft image results when the laser is not focused or powerful enough for the image or size of glass. The glass needs to be of optical quality, ideally with flat surfaces that allow the laser beam to focus and penetrate the surface without deflection. Working with curved shapes is very difficult, due to the refraction of the laser as it goes through the surface: the glass would need to be placed in a bath of optically matched liquid, and that is time-consuming and expensive. Ripples, flaws and bubbles within a glass block will detract from the effect, so this is not a process for use on kiln-cast glass. Using something like a Schott optical block would be ideal, as it is optically pure; however, there are a number of manufacturers producing blocks and these could also be used. Look on eBay or at the end of this book for suppliers (pp. 124–5).

If you are just using a laser to engrave the surface of the glass (further discussed on p. 68), any type of glass can be used.

Micro-flaws

The points or white markings that you can see within a sintered glass block are tiny micro-flaws that are 0.1 mm in size. These are made by focusing a laser on a determined position, where it emits a concentrated point of energy that results in a small fracture at the focal point (tip) of the laser. The laser does not score a continuous line: what appears to be a line is actually a series of small flaws linked closely together. The laser is operated by being pulsed on and off to make each micro-flaw occur. It bounces off mirrors that are mechanically operated and repositioned for every point produced. There could be up to half a million micro-flaws in a single image in a block.

Thickness of glass

Bathsheba Grossman, an artist who has used lasers for sintering and sub-surface engraving, comments on size limitations:

ABOVE Christopher Pearson, *Inside for Life*, 2008. Sub-surface laser-engraved glass for British Airways' First Class Lounge, Terminal 5, Heathrow. Each screen is 320 x 140 cm (126 x 55 in.).
Photo: courtesy of Jeremy Buckland, Vitrics.

LEFT Vanessa Cutler, sub-surface-laster-engraved glass. Two-dimensional sub-surface engraving is used for trophies and personalised gifts, 4 x 4 x 4 cm (1½ x 1½ x 1½ in.)
Photo: Vanessa Cutler.

Bathsheba Grossman, *Insulin*, 2010. Glass with sub-surface laser engraving, 8 x 8 x 8 cm (3¼ x 3¼ x 3¼ in.). *Photo: Bathsheba Grossman.*

In sub-surface laser engraving, some companies find it easier to use layers of 2D images than to generate complex point cloud images, but Bathsheba works in three dimensions.

No laser that I know of can etch through more than about 3½ inches of glass, so that's a hard limit on the thickness. In lateral size, the largest [machine] I've heard of has a 4 x 8 ft bed, which can in principle etch a piece the size of a door. This is rarely done for three reasons:

1. It takes a long time and with that there's a rising risk of something going wrong during the etch, in which case you're likely to lose the whole piece.

2. Big, thick blanks are expensive.

3. The machine can only go a few inches – about 3 in. – before it has to reposition its mirrors to cover a new area. In a continuous design, this causes a gridwork of slight artefacts, not always very noticeable, but from some angles they can pop visually, and this must be taken into account in the design.

 [NB: A gridlock of points can look awkward and may not fit with the design if it isn't planned for.]

Note that her research was done in America so the above does not necessarily apply to Europe, where there may be newer lasers on the market, able to do larger work. For instance, the sub-surface laser at Vitrics can cope with glass up to a thickness of 9.5 cm (3¾ in.) and has a flat bed that is 3.2 x 1.4 m (10½ x 4½ ft). Haven's laser for surface engraving is able to work at a size of 2.5 x 1.2 m (8 x 4 ft).

GEOFFREY MANN

Geoffrey Mann is a Scottish designer who works with a range of materials and processes. His work aims to capture the ephemeral, and give volume and density to the things we cannot see. The laser is just one process applied in his multi-dimensional practice. Of his work *Dogfight* (below), he says:

Dogfight narrates the interwoven trajectory of two moths' playful behaviour upon meeting. The forms encapsulate the ephemeral echo of the moth's erratic trail. *Dogfight* has been materialised through sub-surface engraving technology, an aesthetic reminiscent of veiling; a natural occurrence experienced within the kiln-cast glass process. The natural whispering creates movement within a static object. The glass is optical crystal and appears invisible, allowing the echo to seem suspended in air.

The techniques he employs relate to the material and subject he is discussing. In *Dogfight*, the use of sub-surface abrasion achieves his objective of capturing motion.

Geoffrey Mann, *Dogfight*, 2008. Glass and sub-surface laser engraving, each block 15 x 10 x 35 cm (6 x 4 x 13¾ in.), whole installation 110 x 20 x 35 cm (43⅓ x 8 x 13¾ in.). *Photo: Sylvain Deleu.*

ABOVE Annie Cattrell, *Conditions*, 2007. Sub-surface-laser-engraved optical glass, manufactured by Vitrics, Paris, 375 x 40 x 160 cm (147½ x 15¾ x 63 in.). *Photo: courtesy of the artist.*

BELOW Annie Cattrell, *Conditions*, 2007. Sub-surface-laser-engraved optical glass, manufactured by Vitrics, Paris, 40 x 15 x 15 cm (15¾ x 6 x 6 in.). *Photo: courtesy of the artist.*

ANNIE CATTRELL

Annie Cattrell is an artist working in the UK, who uses a variety of techniques and technologies. She has investigated the use of MRI, functional MRI and FARO scanning. MRI refers to magnetic resonance testing, a medical scanning technique for looking at internal structures, while a FARO scanner is another 3D-scanning device able to capture the internal volume of an object and transfer it into point cloud form. These techniques help to display the transitory and invisible within landscapes and the human form. Working closely with specialists in various areas across science and technology, she forms concepts that interpret unseen items and ideas. *Conditions* uses sub-surface laser engraving to produce the image, catching something fleeting in solid glass. Annie states:

Digital technology offers an interesting new way of representing reality, close to 3D photography. It allows certain freedoms that making something by hand doesn't offer and there is a uniqueness about the quality.

SURFACE ENGRAVING

In surface engraving, the laser works directly on the surface of the glass and not within the glass. The laser operates by moving backwards and forwards along the x-axis (horizontally), emitting a series of small, rapid bursts of heat that creates a flaw or abrasion on the surface. There is no coolant and the quality of the mark is similar to a dry-point engraving. The depth of etch is very shallow – less than 0.5 mm into the surface. The closer together the lines run, the denser the area of engraving. The further apart they are, the lighter the shading of an area. To achieve more contrast, the distance is varied between runs of the laser. If the laser is not focused, the finish is much softer as the line will be blurred.

Detail of a picture engraved on 6 mm soda-lime glass, 110 x 95 x 0.6 cm (43¼ x 37½ x ¼ in.). *Photo: Vanessa Cutler, courtesy of Haven Laser.*

The image is based on a JPG file. Other systems may use other types of files, making the surface finish slightly different. This photo displays the scale at which the laser can work and the detail of image that can be undertaken.

HAVEN LASER

In some cases, memorial companies have surface-engraving equipment for engraving headstones. Before working on a memorial, Adrian Howells of Haven Laser, based in Swansea, will laser images on to 6 mm glass. By placing it over the stone, he is able to check the location and quality of an image before working on the stone itself. The laser has various settings for strength of laser beam and quality, which he changes according to the type of work that he is undertaking. The size of the bed is 2.5 x 1.2 m (8 x 4 ft), one of the largest available for engraving within the UK. For glass, the laser is used at 45–60 per cent of its strength (if used at full power, it could melt the glass). The laser can be operated in two ways: by being pulsed and moved across the surface, stopping at each side of the image, or by a continuous line. This company happily accepts a JPG or Illustrator file for the creation of a 2D surface engraving on glass. Their laser is not suitable for sub-surface engraving.

CHRIS BIRD-JONES

Chris Bird-Jones MA (RCA) is an architectural artist who has used surface engraving alongside photovoltaic cells for a commission in Wales. She is interested in combining technologies and sustainability.

The Cwm Aur glazing scheme incorporated photovoltaic cells into a double-glazing scheme for the front, south-facing elevation of a building that uses the latest environmental technology (see photos on p. 70). The design was based on Welsh quilt patterns, and comprised of laser surface engraving and a combination of other techniques used within the studio, such as screen-printing and surface bonding. It demonstrates a combination of techniques and technologies that can be applied in an alternative manner. Working directly from JPGs, the patterns were transferred to the glass; this work was carried out by Haven Laser.

Access to equipment and processing

You may have to approach different companies to handle the processes of cutting, sintering and surface engraving. Some engineering companies have lasers and are willing to cut forms if you can produce drawings or files they can work from. Other companies may be used to cutting and etching metals, but not glass. However, within the parameters of their software, glass should be a material they can access. For the sub-surface engraving of glass blocks, you need a specialist company that offers the process.

A decade ago, artists wishing to use sub-surface engraving had to go through middlemen and have the work carried out in places such as Russia or China and the quality was not as high as it is now. Now you find many companies offering, via the Internet, to take your picture and produce a sub-surface engraving, although the size is limited. If you wish to generate a three-dimensional sub-surface image, a specialist firm is required and they will need more complex files. See, for example, the works of Langland and Bell, Geoffrey Mann (p. 67), Annie Cattrell (p. 68) and Katharine Dowson. Companies such as Vitrics specialise in the application of the process for public art.

The photos opposite show how sub-surface engraving can be applied to glass ranging from 19–90 mm thick (the glass table is around 20 mm thick and the blocks are around 90 mm).

As previously stated, sub-surface laser engraving produces layers of white, caused by the micro-fractures: it is not a multicoloured process. However, there are some companies now offering a process of surface engraving with colour printing into the etched area, allowing the laser to sinter or fuse the enamel colour to the glass surface. This is not commercially substantiated, as I have yet to see an example

LEFT Bathsheba Grossman, *Hemaglobin*, 2010. Sub-surface laser engraving, 8 x 8 x 8 cm (3¼ x 3¼ x 3¼ in.). *Photo: courtesy of Bathsheba Grossman.*

BELOW Arik Levy, *Glass Table*, 2006. Sub-surface laser engraving, manufactured by Vitrics, 130 x 50 x 1.9 cm (51¼ x 19¾ x ¾ in.). *Photo: Arik Levy.*

that shows the viability of using such a process creatively. However, I do see artists looking at applying enamels by laser in small experimental pieces, which may lead to more developed work in the future.

COMMERCIAL APPLICATIONS

Laser cutters have some very commercial applications. Several companies will offer to create a souvenir of a time or occasion you wish to celebrate. Three-dimensional forms are produced by terrain-mapping software within a darkened room and, within minutes, the surface of a glass block is etched. Companies may use a 3D scanner or work from multiple 2D images.

Sub-surface engraving is being applied for items such as trophies. One company has found that due to the intricacies of programming, they only use the machine for 2D forms; for 3D forms, the time spent programming and having to change the set-up is not viable. Instead, they build a 3D image by layering images. This way, they might produce three programs for one block, but there is still only one set-up charge and the process is cost-effective for the customer and the company. Kirsteen Aubrey's *Icicle Garden* (pp. 8, 123) was carried out in such a way, with a 2D image being sub-surface engraved into a 3D block.

Costs

For cutting, the costs are mainly based on the thickness of the material. There are no tooling set-up costs, but there will be software programming time to account for. A clean file (one that needs no further alterations) should be handed over to the company for programming. It should be a complete file with no unresolved elements. If it is a vector file, all points should be closed.

BELOW LEFT Laser-engraving machine. The glass is placed against a 90-degree metal plate, like a set square, to align it. (At Vitrics, Lego may be used to register the block – see p. 57). *Photo: Haven Laser.*

BELOW RIGHT Setting the height of the laser. The laser has a set height allowance to allow it to travel safely across the glass. *Photo: Haven Laser.*

Sub-surface engraving is quite expensive, depending on whether you are having a 2D or 3D image inserted into a block. The cost will also depend on the complexity of the design, production quantity, laser quality and number of point clouds. You need to work within the limitations of the machine that the company owns. A one-off piece will cost £300–400. However, if you were having something done in multiples, similar to the small engraved blocks seen in gift shops, the costs would work out considerably lower.

For surface engraving, the approximate cost for use of the laser is £1–2 a minute. For example, one company charged approximately £120 per square metre at the time of writing. To engrave a piece of glass measuring 2.5 x 1.2 m (8 x 4 ft), which is the maximum size that the machine will accept, would take just under 12 hours and cost about £1,400. Most works will be much less, but the complexity of the design is something that needs to be taken into consideration.

ABOVE The laser travels vertically across the glass. It moves continuously, pulsing its beam to create a dull fractured surface. *Photo: Vanessa Cutler, courtesy of Haven Laser.*

LEFT This shows a laser-engraved surface. The result is similar to that achieved with sandblasting, but instead of continuous coverage, the image is built up with multiple white specks. *Photo: Vanessa Cutler, courtesy of Haven Laser.*

4

Multi-axis machining

The machining of glass covers a vast range of possibilities, from cutting and drilling to milling and polishing. It is used heavily within the optics industry, where high precision is needed, and also to manufacture mirrors, prisms, lenses and filters. Often the required tolerances or size requirements are so tight that only a machine can produce the dimensions required. Glass artists have started, like many designers, to use processes that have been available to industry for years. Recently, the increase in the application of digital software and technology in our work has meant that some sort of machining will probably be required in order to realise our ideas.

Glass artists may apply both single-axis and multi-axis machining (see p. 30–1), often through processing the glass at local glazing and glass companies. For those who work with glass for furniture, or for any type of edge finishing, machines are often used. Within this chapter, the focus is on more complex multi-axis machines and how they may aid creative development.

What is multi-axis machining?

Multi-axis machining enables materials to be cut, abraded and milled into accurate forms. Whether a machine is single-axis or multi-axis determines the plane on which the work is machined. Many of the machines, such as water-jet and laser cutters, are mentioned in other chapters; this chapter expands on that information and discusses some different types.

Prior to the introduction of these technologies, traditional tools have included the glass-cutting carbide wheel, and for engraving, something like a Dremel tool, a small tool with a motor, again held and controlled by hand. There are also automated machines for engraving, if using a lathe, where an operator holds the work and controls the depth of cut on a wheel, each one being marked out by hand and done by eye.

Machining companies have been working with stonemasons, carvers and sculptors such as David Edwick for several years to carve 3D stone and concrete pieces, and as the technology advances, it can be used on more materials.

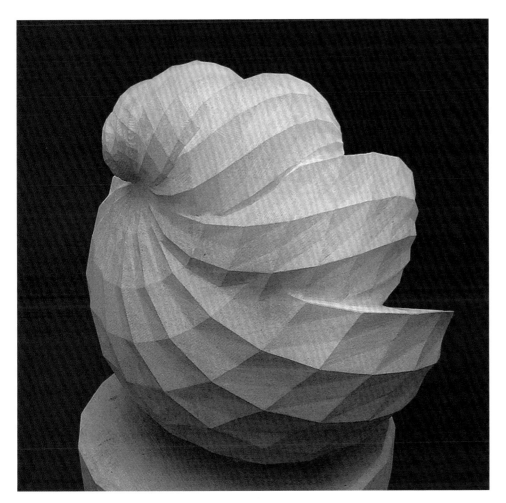

ABOVE The design for David Edwick's *Shell* is scanned by a five-axis machine's software to program the cutting paths for the milling machine. *Photo: David Edwick.*

LEFT David Edwick, *Shell*, 2007 (detail below). Portland limestone, designed in Autodesk 3D Studio Max. The design is based on a triangulated rendering of the sphere, which has been scaled and rotated to create a spiral form reminiscent of fossil sea creatures, 50 cm (19¾ in.) high. Made for his MA degree show, now in the collection of the artist. *Photo: David Edwick.*

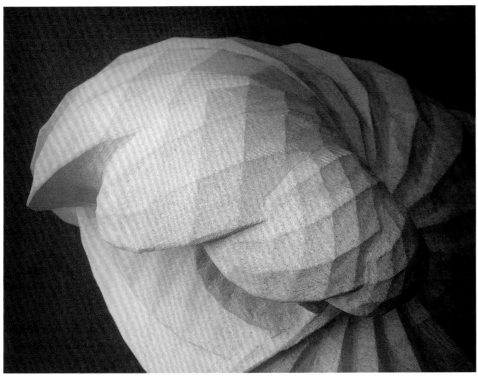

Multi-axis machining for glass artists

Glass artists may use multi-axis machines to have work cut or developed for multiple or component-based pieces. The expense of such machining may be worth the cost in terms of speed and accuracy; also, the cost depends on how much preparatory work you undertake yourself. If you can produce files that meet the requirements of the machine, it will keep costs down. Complex multi-axis machining is not the only thing on offer. Machines can also do precision cutting, profiling and drilling, with various finishes and edge effects. Internal cut-outs, including perfect holes, can all be cut and polished. All these processes can be done more quickly by machine than by hand and are primarily used within the flat glass sheet industry. Machining companies can make pieces that are fully bespoke, cut from templates or your own drawings. Incredibly accurate, the finish is of the highest quality.

In the past few years, artists such as Richard Whiteley, Shelley Doolan, Aimee Sones, Donald Friedlich and Geoffrey Mann have employed five-axis machining to good effect in their work. Even commercial companies have used it to manufacture moulds for pressing, casting and blowing. Often the processes include laser marking, carving and machine milling. Many companies can help with the development of forms prior to casting or the making of moulds, profiling and shaping materials such as foam board, polystyrene, fibreboard and even wood. Michael Eden, for example, uses wooden moulds for glass vases.

ABOVE Five-axis milling machine at Advanced Glass Technologies.
Photo: Advanced Glass Technologies.

RIGHT Five-axis milling process. Glass is set into the jigs. The machine will abrade the glass surface away using a lubricant.
Photo: Advanced Glass Technologies.

LEFT Machine-polishing large, cast glass sheets. The person in the picture is throwing pumice on the glass to help the process along.
Photo: Richard Whiteley.

ABOVE End result of the machine-polished recycled glass.
Photo: Richard Whiteley.

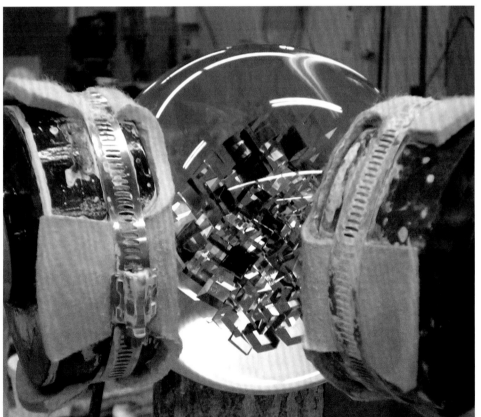

ABOVE Example of a part produced via multi-axis machining.
Photo: Advanced Glass Technologies.

LEFT Sphere polishing to produce an optical-quality finish.
Photo: Advanced Glass Technologies.

ABOVE Using a scissor lift to load a 1.52 m (5 ft) blanchard grinder with 1500 kg (682 lbs) boule, as the glass is too big to be worked manually.
Photo: courtesy of Christopher Ries.

CHRISTOPHER RIES

Christopher Ries (USA) produces monumental glass sculptures that require a degree of machining to enable the work to be produced. In some cases the glass can weigh over 450 kg (1000 lbs).

In the 1980s, Christopher started buying glass from Schott and realised that the company was unmatched in the manufacture of large optics. In buying the glass and producing beautiful work he attracted the attention of Dr Franz Herkt. Christopher was invited to exhibit work at Schott's centenary in Washington DC, and due to the response to his work, was invited to become artist-in-residence.

The relationship has continued to this day and provides an amazing insight into how industry and artists can have a wonderful symbiotic relationship. Both Schott and Ries co-own the work produced. When it is sold, the money recovers the material and machining costs. Ries occupies a small space at the factory, with access to all the resources. He also has an independent studio for making work which he can upscale at Schott. He works around the schedules of the factory and utilises machines when they are not working on production.

Ries does stress he is first and foremost a studio maker and not an industrial designer; he has always been an independent maker producing one-of-a-kind pieces and wants to work with the finest material available to him. Schott offers that, as well as access to facilities and equipment not available to the individual studio.

Ries has often been told he is lucky. His response is: 'Luck favours the prepared mind.' Maintaining a good relationship with a company, no matter how small or large, can lead to positive outcomes.

ABOVE Placing metal braces on the magnetic table of the large centreless grinder: the glass needs to be kept in place and level.
Photo: courtesy of Christopher Ries.

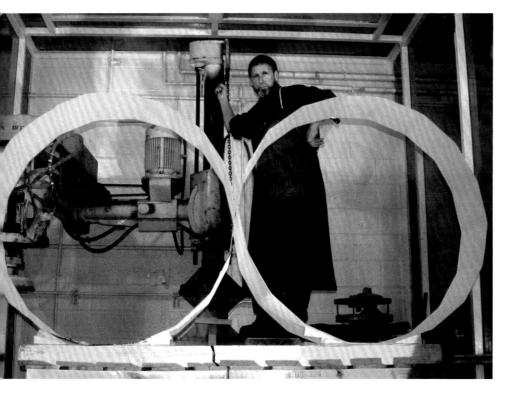

ABOVE Test-polished large boules of optical glass, ready for inspection. *Photo: courtesy of Christopher Ries.*

ABOVE Grinding *Spring*, cast in plaster-filled ring, 2010. *Photo: courtesy of Christopher Ries.*

ABOVE Wire-sawing a large, test-polished block using silicon carbide slurry as an abrasive. *Photo: courtesy of Christopher Ries.*

ABOVE Sculpting *Spring* with a compressed-air-powered grinder, 2010. *Photo: courtesy of Christopher Ries.*

Christopher Ries, *Spring*, 2010. Cut, ground, polished and engraved optic crystal, 104 x 51.5 x 15 cm (41 x 20¼ x 6 in.). *Photo: courtesy of Christopher Ries.*

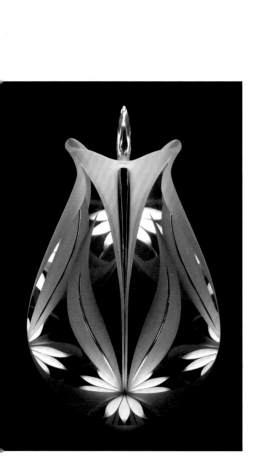

ABOVE Christopher Ries, *Internal Reflections of Sylvan Flora*, 2008. Cut, ground, polished and engraved optic crystal. *Photo: courtesy of Christopher Ries.*

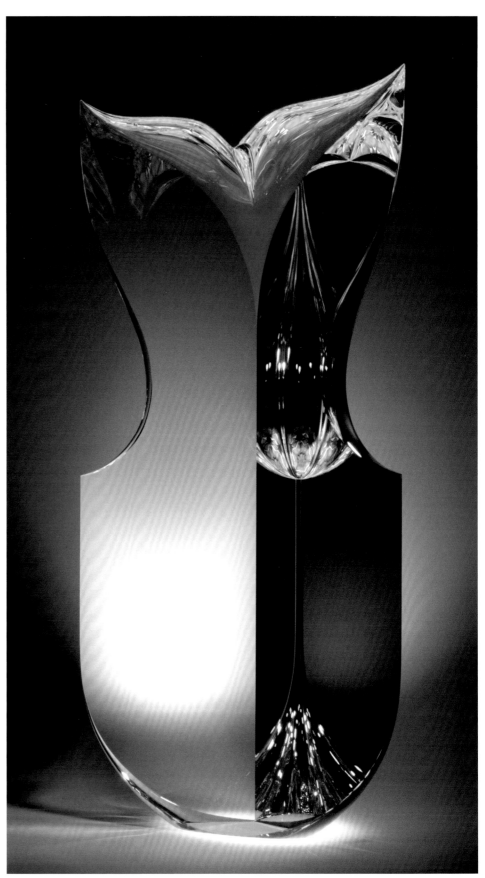

Moulds and formers

Machining is being used by glass artists to produce the formers and moulds in which to cast their glass, working with materials such as moulding board, wax or plaster. The process is good for detailing, accuracy and producing reliefs, either positive or negative, that enable highly engineered detail (engineered detailing refers to the production of geometric forms that are identical). The jeweller Donald Friedlich has used the process to make graphite moulds and Ross Head has used it to make moulds for glass blowing and pressing. Zak Timan has used the process for machining quartz.

The finish of the glass object very much depends on the level of detail included in the file that will produce the mould and the experience of the programmer/machinist. The runs taken by the milling head govern the coarseness and precision of the cut. Like most processes, the quality of the outcome also relies on the relationship between the artist and the person producing the work. Bear in mind the fact that these machines have to produce parts for industry, where tolerance and accuracy are far tighter than you may expect (in the aeronautical or aerospace industries, a size difference of 0.001 cm is unacceptable).

There are not many specialist glass machinists, but for making formers or moulds, you can approach local machining companies who work with the material you wish to use. General engineering companies may be willing to undertake a series of trials, but the outcome will be uncertain. If you can develop a good dialogue with a company, they may be willing to be more experimental; however, don't expect this straight away, as they will not want to risk damage to their equipment.

SHELLEY DOOLAN

Shelly Doolan is a UK-based glass artist who has been using technology to create her work since 2006. She graduated from Farnham and has researched the use of rapid prototyping and the water-jet machine. Within her series of work *Iteration 463*, Shelley has applied machining to manufacture forms for moulds. This enabled her to create the crisp and distinctive forms and texture seen in her work. She works in RhinoCAD and SolidWorks to build a 3D form, which she exports as an IGES file (another type of vector file that is suitable for the company she works with). This informs the milling head as it traverses the material.

Shelly describes her project *Iteration 456* as follows:

The interaction between glass and light has been my overriding preoccupation. The effect of varying the density of glass and colour through modelling and relief detail has long been of interest. With this in mind, I designed a series of glass panels that exploited these material effects and explored the theme of the interaction and collision of wave forms.

Using a mathematical plug-in for 3D modelling software, I generated the forms, which are based on equations. Not being overly burdened with mathematical knowledge, I felt free to vary the parameters of the equation

Milling a tile: the tool is effectively 'carving' out the detail.
Photo: Shelley Doolan.

Shelley Doolan, *Iteration 137* (detail of surface), 2010. Cast glass, 76 x 26 x 4.5 cm (30 x 10¼ x 1¾ in.). *Photo: Simon Bruntnell.*

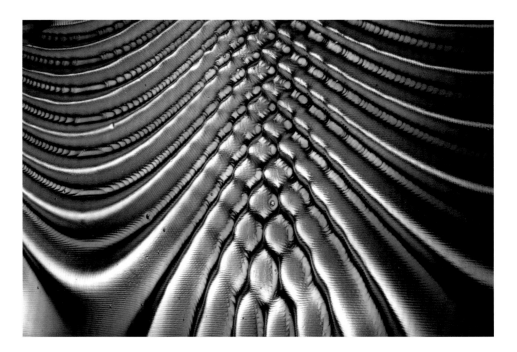

in a lengthy process of exploration and form-finding, akin to a process of 'virtual sketching'.

Having generated the models, the issue of how to make the intangible tangible arose. Given the nature of the forms and their creation, I wanted to have a direct relationship between the 3D computer model and physical model, rather than interpreting it by sculpting by hand. As the pieces were quite large, rapid prototyping was impractical. I decided to have the forms routed to create a physical model from which refractory moulds could be taken for subsequent kiln casting.

I was fortunate to have a good deal of cooperation from subcontractors to help me to make decisions about the process of routing, which resulted in the satisfactory production of models. With the production of the physical model, the process of creating the objects in glass reverted to traditional casting and lengthy hand-polishing methods.

As with most making activities, the more that you can find out about the process and the variables, the closer you get to achieving your desired result.

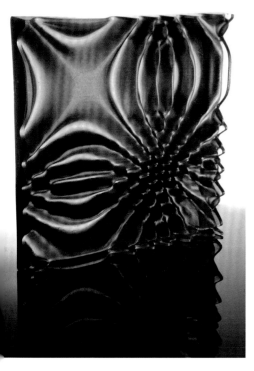

Shelley Doolan, *Iteration 456*, 2010. Cast glass, 76 x 26 x 4.5 cm (30 x 10¼ x 1¾ in.). *Photo: Simon Bruntnell.*

There are a number of options to consider for this type of work, including tool shape and size, cut path pattern, the step-over of tool paths, number of passes and the spindle speed and feed rate. The selection will depend on the material used, as well as the geometry of the model and the quality of finish (and hence cost) of the model.

It is here that the experience of the programmer and operator is of such benefit. Shelly comments: 'Whilst it is impractical for most of us to have direct control over the process, I have found that it has been possible to realise my design intent through working with skilled professionals who are able to articulate the range of possibilities and probable outcomes, enabling me to make informed decisions.'

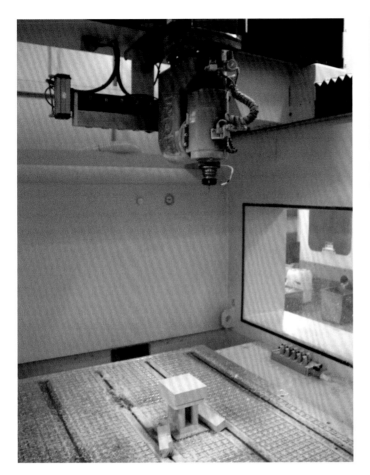

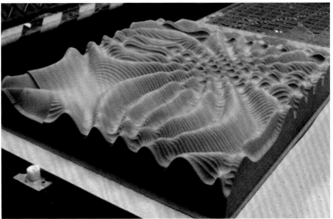

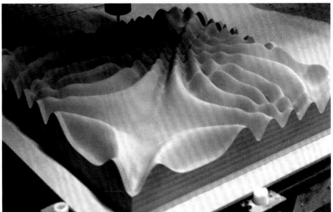

ADVANCED GLASS TECHNOLOGIES

This machining company, based in Rochester, USA, has been offering specialist services to glass artists for many years. Anne Marino, engineering specialist at Advanced Glass Technologies, explains the process:

Working here, most glass that goes through the shop winds up on multiple machines before we are through with them. In general, we take a look at what the customer is asking for, and then figure out how best to make it using the variety of equipment and tooling we have. A complex part might have some sides ground on a rotary grinder, some curves generated on a CNC machine, and some edge features cut out on the water-jet ... and then our customers take the parts and process them further. A whole range of shapes can be produced, depending on what the customers need.

In terms of files, we work with Mastercam for our CNC machines, although we can convert a variety of solid file types from various CAD programs. I would say that's the preferred option if it's available, because it provides the exact shape the customer is looking for. We can also generate the required files here, based on a drawing. In that case we might expect the machine operator to come back with questions if he is unsure of how to interpret the drawing. The more someone can specify the shape needed,

ABOVE LEFT Set-up for the milling machine, with the small block to be milled in the centre.
Photo: Shelley Doolan.

ABOVE TOP AND BOTTOM Differences between roughing and finishing passes with the milling tool.
Photo: Shelley Doolan.

The images illustrate the difference between a 'roughing' tool pass and a 'finishing' tool pass. The first photograph was taken part-way through the finishing process. As you can see, the finishing pass is much finer and leaves a good-quality surface on the model. Depending upon the geometry of a model, it may be possible to smooth and refine the surface by hand.

the easier it is for a machine operator to achieve that shape. It's always easier to start out with something, be it a drawing that can be scanned in, or a computer file.

Companies such as Advanced Glass Technologies have a multitude of equipment such as five-axis machines and two-axis milling machines, which can work to tight tolerances. Use of the five-axis machine is very much dependent on the part, and size, shape, material and tolerance all play a role.

RICHARD WHITELEY

Richard Whiteley is an internationally renowned glass artist, who in his recent series of works has been using CNC profiling to help generate the initial form for his castings. His interest in light and volume is displayed in this work. He uses carved polystyrene and the lightness of the material and the shaping of the formers have generated ideas for outcomes in glass.

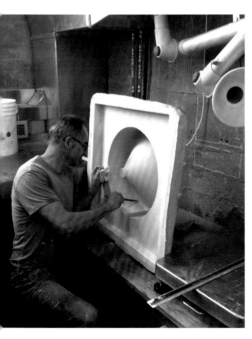

ABOVE Manufacture of moulds. This shows the production of the plaster mould following the removal of the machined former. *Photo: Richard Whiteley.*

RIGHT Richard Whiteley, *Light Mass*, 2011. Cast glass, 36 x 36 x 11.5 cm (14¼ x 14¼ x 4¾ in.). *Photo: Greg Piper.*

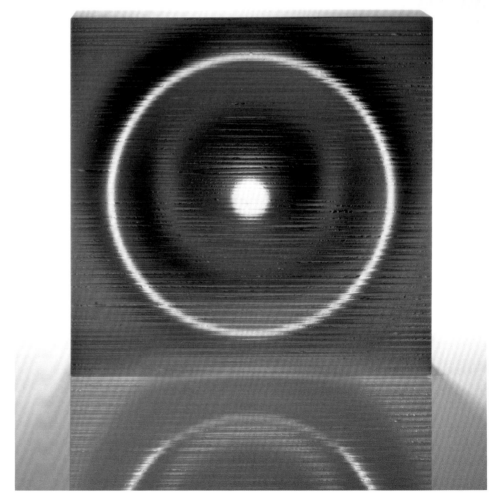

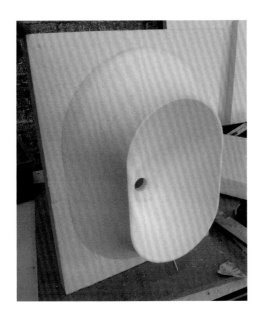

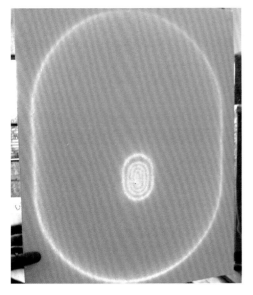

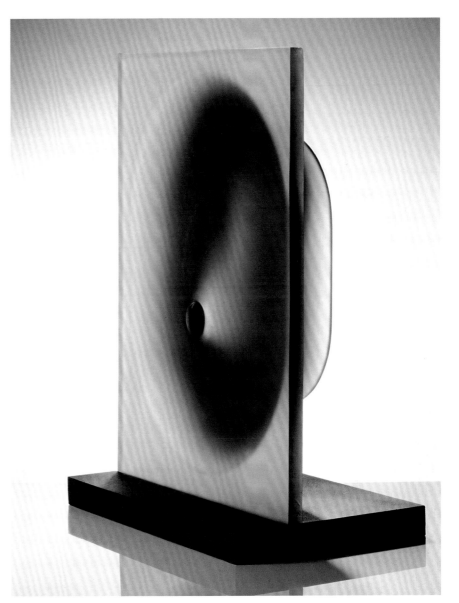

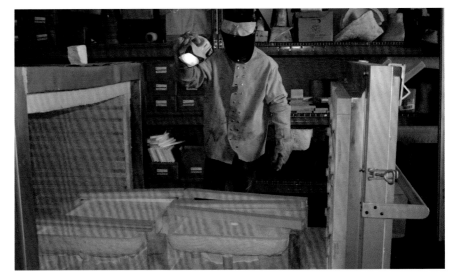

TOP LEFT A machined former. *Photo: Richard Whiteley.*

ABOVE LEFT The effect of light shining through a former. *Photo: Richard Whiteley.*

ABOVE RIGHT Richard Whiteley, *Cavity*, 2011. Cast and carved glass, metal, 70.5 x 48.5 x 32.5 cm (27¾ x 19 x 12¾ in.). Held in a private collection. *Photo: Greg Piper.*

RIGHT Casting the glass into plaster moulds. *Photo: Richard Whiteley.*

DONALD FRIEDLICH

The US jeweller Donald Friedlich works in glass and has combined traditional practice with CAD/CAM technology. He has used a multitude of processes to produce his work, ranging from water-jet cutting to 3D printing. His work, which is held in multiple collections, looks at the translucency and optics of glass alongside traditional and contemporary jewellery-making techniques. He states:

I'm first and foremost trying to realise my artistic vision and make the designs that are in my imagination. These days, those ideas are best realised by the use of CAD with CNC machining of graphite moulds. The combination of these processes has completely opened up my form options in glass.

I've just started working with rapid-prototyped glass. While it currently has some restrictive limitations, I see lots of potential for further exploration and development. I've done a little work with water-jet and laser-cutting and I'd love to do more when the equipment is available to me.

I'm also interested to see how other artists are making creative use of industrial processes in order to allow them to either make work that would be nearly impossible by any other means, or to improve the practical and financial viability of their designs, be they one of a kind or production work.

Within the *Translucence* series produced in 2009–10, he employed the machining of graphite moulds and water-jet cutting. The graphite moulds allowed the glass to be pressed and moulded to create the pure form. Water-jet cutting created small, linear gaps within the body of the glass, adding translucency within the glass form.

The use of graphite is very popular with artists, however many job shops are not too willing to machine it as it has a tendency to cover everything, making the clean-up operation difficult and time-consuming. It is also combustible in large amounts. Donald has found it best to track down companies that do electrical discharge machining, who are predisposed to work with the material. He describes the making of his graphite moulds:

The first generation of my graphite moulds I machined myself [in] the old-fashioned way, with a hand-controlled mill. Later, I was a visiting artist for a week at Kendall School of Art and Design in Michigan. I spent half the time with the students, lecturing, doing demos and critiques, and half the time with the faculty head, Phil Renato, playing with their very cool high-tech toys. Phil is fluent in many CAD software [types] and he was also able to machine the next generation of moulds at Kendall.

In my own work, I have used commercial photo etching of sheet metal for some production items. A very efficient and cost-effective process, as unlike water-jet, details don't matter or add to cost. The whole sheet is etched at one time from one side, then from the other. You can have a half-etched area that is only etched from one side. This is a score and fold line, or design element. Or you can have a full etch which cuts halfway through from both sides to pierce the sheet.

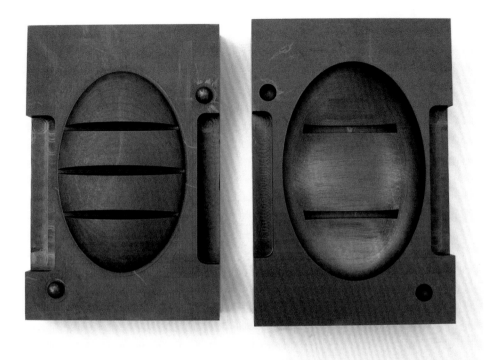

Donald Friedlich, two-part graphite mould for press-moulding hot glass, 2009. Designed in Rhino and CNC-carved by Cate Machine Shop. The design is from Friedlich's *Translucence* series. The mould is approximately 7.5 x 13 x 2 cm (3 x 5 x 7/8 in.). *Photo: Donald Friedlich.*

Donald Friedlich, brooch from the *Translucence* series, 2009. Glass over niobium, set in 22-carat gold, 7.6 x 5.4 x 1.3 cm (3 x 2⅛ x ½ in.). *Photo: Donald Friedlich.*

Zak Timan, parts for *Prakashakaya*, 2009. CNC-machined glass, disc for the base 30.5 x 0.95 cm (12 x ½ in.).
Photo: Dave Lam.

ZAK TIMAN

Zak Timan is a sculptor and glassblower from Berkeley, California. For his work *Prakashakaya*, he chose to use quartz glass and found a company called Hayward Quartz, based in California, which had a specialist machining shop able to work with the size of glass he required.

Zak used fused quartz glass for his columnar, oil-filled sculptures because he wanted a glass tube that was taller than a human. Normally, borosilicate glass would have been the obvious choice for this purpose, but those tubes only come in lengths of 1.5 m (5 ft) off the shelf. He discovered that fused quartz tubes, commonly used in the semi-conductor industry, often come in longer lengths. Further investigation revealed that quartz had a number of other unique properties ideal for the project. Zak explains:

The column itself is made from a factory-extruded fused quartz tube, 190 mm wide and 6 ft 3 in. tall. The machining of precision parts and the capability to 'weld' those machined parts to tubing (concentrically via a lathe) or to other fused quartz parts is very common in the industry. This is just what was needed for the work. Along with the machining capabilities, an extremely low expansion rate offers fabrication techniques and possibilities that would be very difficult or impossible with other types of glass.

The low expansion offers stability of the sculpture in practically any weather condition. Because of its high purity, it has no green or blue tint, as most other glasses do. Its optical clarity is stunning, allowing for the oils and imagery to be viewed clearly, without too much distortion.

The lid of the column and the disc that makes up the base were fabricated separately from the tube. To make these, a solid cylinder was core-drilled from a monolithic block of fused quartz. This cylinder was then sliced into discs on a diamond saw and these thin discs were machine-ground with diamond bits to the proper thicknesses for the base and lid.

The disc for the base (12 in. wide, 3/8 in. thick/30.5 wide, 0.38 cm thick) was fire-polished and annealed at 2154°F (1179°C). A loop was fused to the base as an anchor point for the floating sculptural elements and then annealed again. It was washed with hydrofluoric acid, rinsed with de-ionized water, fire-polished and annealed a third time. This disc was then fused/welded on to the prepared tube on a lathe using hydrogen- and oxygen-fuelled torches and once again the entire assembly was fire-polished and annealed.

For the column's lid, a three-axis CNC router with diamond tooling was used. A gland for an O-ring was ground into the edge of the lid disc, as well as a smaller diameter for the bottom to allow it to seat inside of the tubing. After machining, this disc was also fire-polished and annealed.

Zak describes the whole process of having work manufactured as follows:

Aesthetic concerns can often throw a monkey wrench in the industrial process. Rather than [being] a primary factor as they are in art, they are usually a secondary [factor] in industry, if they are even considered at

ABOVE Zak Timan, the lid for *Prakashakaya*, 2009. CNC-machined glass, disc for the base 30.5 x 0.95 cm (12 x ½ in.). *Photo: Dave Lam.*

LEFT Zak Timan, *Prakashakaya*, 2009. CNC-machined glass; the column itself is made from a factory-extruded fused quartz tube, 19 x 19 x 190 cm (7½ x 7½ x 74¾ in.). *Photo: Wilfred J. Jones.*

all. Extraordinarily clear communication is an absolute must to prevent putting their time, and your dollars, into work that you don't like. Consider contracts ... [in order] to prevent misunderstandings. This is especially important for blown or organic parts that are open to interpretation, but also for edge finish, surface quality and other attributes that don't normally matter for the part's industrial function, but may for your vision. Think about the variables in the part. Sometimes simply e-mailing a drawing file is not enough. Assume nothing.

Look at it from their perspective – they are used to blueprints that outline dimensions down to thousandths of an inch. They don't read minds, or even attempt to. You need to make the decisions, and make those decisions crystal clear to them.

Routing

A CNC router is a cheaper alternative to the industrial milling machine. It is a piece of equipment that has become popular within schools, studios, research centres and universities as well as commercial companies. For glass artists, it is an ideal machine for profiling formers in softer materials such as model board, polystyrene, plastic and plywood. It is good for profiling and shallow relief work, which you can then take plaster moulds from. Glass artists who are making stencils for painting and frit work can use a router to work mouldings in plastic. Routers can also mill aluminium.

The process of manufacture is the same as with many of the processes previously described: a toolpath has to be created, usually from an STL file, in software such a RhinoCAD. A toolpath is the direction that the router's tool-head will follow and is dictated by CNC code. With routing, the profile needs to be more three-dimensional, which is why software such as RhinoCAD is most suitable.

The router works by moving on the x-, y- and z-axis. The tool-head for a router works by spinning around; it looks similar to a drill part, but rotates instead, traversing the surface to remove the dictated parts of the material, using the edges and tip of the spindle. Some routers only work on an x–y axis, with a fixed head. In these instances, the head passes over the surface multiple times, taking a small amount away with each path until the desired depth of cut is met. Machines such as the one used at the Haystack Mountain School of Crafts' fab lab, a ShopBot CNC router, is suitable for all types of materials, from aluminium to polystyrene, working on three axes and with the ability to do more 3D work. Most secondary schools in the UK have small routers suitable for working with plywood and plastics, for engraving, and to cut material in multiple passes.

The principles of the CNC router are essentially the same as those of the more complex machinery described in this chapter, but milling machines used within engineering use more axes and have much more complex profiling software. In general, the finer the spindle head, line passes and overlap of the toolpath, the finer the surface quality will be, although this depends on the material used.

Costs

The cost of multi-axis machining is very dependent on the type of machining required. Of most machining processes, routing is probably the cheapest, but that too is dependent on the complexity of shape required.

Specialist machining companies can deal with very complicated work. However, the machines are themselves very complex and expensive to run and purchase, so overheads are high. Don't expect this to necessarily be a cheap option. If you are deciding to work with such a company, consider not only the machining time, but the time it will take for programming. The cost can vary from £60–150 an hour; this is similar to the cost for other machines and labour. Individual companies, such as Advanced Glass Technologies, will give a quote based on the work they anticipate doing. Every job is different.

Realistically, glass artists wanting to have their work carried out by a company are more likely to be asking for some form or shape to be made from steel or polystyrene, as in Richard Whiteley's recent work (pp. 84–5). If you have the drawings and the complete files, the minimum costing would likely be £100, but it must be stressed that the complexity of the form and the scale of the object will affect the price. If it is just a simple former to be made, such as steel sheet bent into a curve, the cost may be somewhere between £15–30.

The more prepared your drawings and files are, the more informed the discussion with the company will be and the lower the cost. If you are leaving the entire mechanics of creating a form or mould to a company, the costs will be higher.

5

Rapid prototyping

In the past few years there has been an interest in applying more complex technology to traditional skills within the glass studio. Although rapid prototyping, including 3D printing, is expensive, it is proving to be a useful addition to the skills base of glass artists.

The process has been used in several design fields to develop designs and prototypes for multiples or one-offs. It can assist in working through a design idea quickly, without having to work directly in the material (which is especially relevant if the material is expensive). Companies such as Denby have used the technology to help envisage shapes of handles for their ceramics, allowing them to try several different styles before committing to production. Many universities, including University College Falmouth, Swansea Metropolitan University and MIT's fab lab, as well as research centres, are offering rapid prototyping as a method of production for students and design companies.

Even as this book was being written, rapid prototyping was expanding to include advanced mould-making and kiln-forming processes. Many artists are already using rapid prototyping, such as Michael Eden, Tavs Jorgensen, Shelley Doolan, Antje Illner and Bathsheba Grossman. For the glass artist, this is a process to be subcontracted to a specialist, although the artist can do most of the preparatory work.

What is rapid prototyping?

Rapid prototyping can be an additive or subtractive engineering process, which is carried out in a variety of ways. A design for a form is produced in CAD software such as RhinoCAD and transformed into cross-sectional layers. The rapid prototyping machine then processes this information (the standard design file interface is an STL vector file) and uses it to make the form by building up very fine layers of a material, which are then fused together.

Rapid prototyping can be done with a multitude of materials, such as wax, metal, polymers and even paper, and any shape can be produced. The typical applications

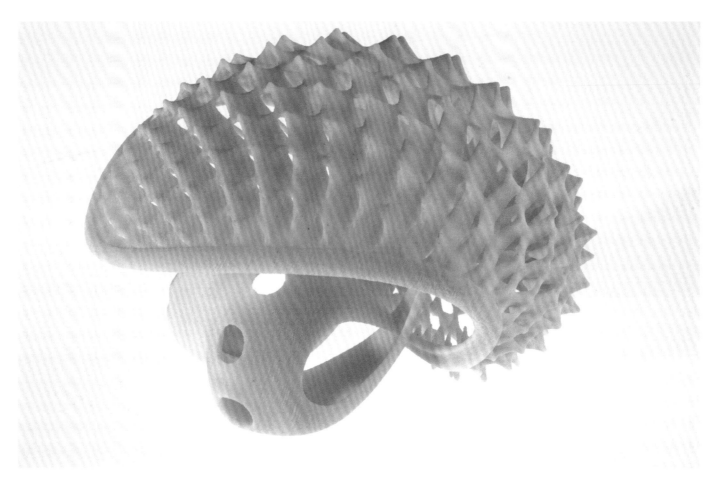

Bathsheba Grossman, *Tuskshell*, 2010. Soda-lime ballotini, produced by the ExOne Co. 3DGP process, available for purchase from Shapeways, 9.2 x 7.9 x 8.4 cm (3½ x 3 x 3½ in.). *Photo: Mike Shepherd, courtesy of The ExOne Co. and Bathsheba Grossman.*

of such technology are in the manufacture of prototypes and samples. The process can also make forms that are plated and used as parts in their own right.

There are three main processes: FDM (*fused deposition modelling*, which is plastic-based), SLS (*selective laser sintering*, which works with a variety of materials including ceramics and metals) and SLA (*stereo lithography*, which is resin- and wax-based). Additional processes include DMLS (direct metal laser sintering), for metals, and LOM (laminated object modelling), which is paper-based.

Some of the rapid prototyping processes are more expensive than others and suited for particular applications. Glass artists often only require one or two pieces, not hundreds of multiples, so the expense of manufacture may not be cost-effective if you are making a one-off piece, unless the budget/commission can cover those production costs.

FDM (FUSED DEPOSITION MODELLING)

In this method, the form is designed using a CAD software program such as SolidWorks, which produces an STL vector file. This will then be converted into CNC code to develop a tool path that the machine can follow. The form is produced in multiple layers by extruding images layer by layer in a manner similar to that of an inkjet printer. The extrusion nozzle of the machine runs across a surface, putting down layers of molten plastic: hence the term 'fused deposition'. The application of

ABOVE Rapid prototyping machine at Swansea Metropolitan University. *Photo: Vanessa Cutler.*

RIGHT Examples of parts made by rapid prototyping. *Photo: Vanessa Cutler.*

FDM for a glass artist would be in the manufacture of formers for mould-making rather than the direct generation of a form. It is not a process for using directly with glass. Within the manufacturing industry, it is used for modelling and small batch production.

SLS (SELECTIVE LASER SINTERING)

SLS uses a high-powered laser to fuse small particles of material together to form an object. The form is generated from powder that surrounds the object as it is being built. The difference between SLS and the other two rapid prototyping processes is that the part is totally supported by a loose powder at all times. A variety of materials can be used within this additive process, from plastic and sugar to ceramic powders.

SLA (STEREO LITHOGRAPHY)

This process uses an ultraviolet photopolymer resin to build up a form in layers, using an ultraviolet laser. Working with an STL vector file, the software supporting the machine will generate the CNC code to create the form. When the resin is exposed to the laser, it becomes solid. The form rests on a platform in a sink of ultraviolet resin and the platform moves downwards into the resin after each layer has been formed. The laser only touches the area of the part to be generated.

Prototypes made by SLA are often strong enough to be machined, or to become the finished part. This process is the most widely used within manufacturing, as it is the most accurate and gives a high-quality surface finish. As with all rapid prototyping processes, there are no tooling costs; because the form is built up from powder, no specialist formers or jigs are required to support its manufacture. However, the process is expensive and the manufacture of forms can be limited. The SLA process is used within manufacturing for the production of models, prototypes and even production components.

Rapid prototyping for artists

For artists and jewellers working in glass and metals, rapid prototyping helps in the manufacture of moulds and parts that are either functional or decorative. An initial form can be created using any of the three processes, and from that, multiple moulds may be produced.

In some instances, the application of technology is noticeable in the finished form; in others there is little indication that new technology has been applied. For many jewellers, the application of this technology has become standard practice. Rapid prototyping is ideal for small-scale work that is going to be produced in multiples, as it makes the cost viable. Artists such as Justin Drummond and Phil Renato have demonstrated how complex forms and structures can be used in the manufacture of jewellery in a variety of materials.

An understanding of the procedures and parameters is essential for achieving good-quality forms for repeated use. It is worth remembering that with processes such as rapid prototyping and automated machining, the item can look machine-made, with a surface texture that shows tool paths (some people may welcome this).

3DP (three-dimensional printing)

3D printing (3DP) is yet another rapid prototyping methodology, originally developed at MIT. Several companies are currently providing services and developing processes that fall under this general heading. While all 3DP methods

Justin Drummond, *New Matrix Necklace*, 2011. Artist's collection, selective laser sintered, nylon, 33 x 33 x 40 cm (13 x 15¾ x 15¾ in.).
Photo: Justin Marshall.

share similar modes of operation, the technical capabilities and available print mediums can vary significantly between service providers.

Three-dimensional printing systems have remarkable flexibility. This additive, free-form fabrication process can build parts of almost any geometry. Designs including undercuts, overhangs and internal cavities are possible. It can create these forms from almost any powdered material, including plastics, glass, ceramics and metals. Using a technology similar to ink-jet printing, specialised print heads selectively apply liquid binders to sequentially-added layers of powdered media, literally building a design object from the ground up, one thin layer at a time.

To accomplish the *build* process a computer (CAD) model is first subjected to a slicing algorithm. This converts the computer model into a detailed series of vertically stacked layers. The machine process begins when a hopper-like mechanism, known as a re-coater, spreads a thin layer of around 1 mm ($^1/_{40}$ in.) of powdered media onto a movable platform, known as the build table. Four fixed, vertical walls surround this table. This assembly is known as the build box and it serves to constrain the successive build-up of the powder media. The layers of powder make up the powder bed. As parts are being formed, the powder bed itself completely supports the part-in-progress so no secondary materials or added scaffolding are required. A mechanical piston attached to the table allows the powder bed and the emerging part to move downward, so that after each pass of the print head, the table descends one increment and the re-coater spreads a fresh layer of powdered media on top. This layer-on-layer process repeats until the part design is completed. When the build process is finished, the build box is completely filled with un-bound, in which the newly formed 3D part is nestled.

The build box is carefully drained of excess powder, which may be recycled. In the case of glass, ceramic or metal parts, the emerging green parts will now be subjected to a thermal sintering process to burn off the binders and consolidate the part into a near-finished state.

3D GLASS PRINTING

Artists working in glass and ceramics have proved that 3D printing can be used with dramatic effect. Michael Eden, Tavs Jorgensen, Philippe Garenc and Bathsheba Grossman have all used it.

The figures opposite demonstrate how Bathsheba Grossman uses RhinoCAD to develop her forms (which are often derived from algorithms) into structures. She is a trained scientist, exploring the natural beauty of mathematics. Her great skill is to make numbers visible in the form of real three-dimensional objects: she actually visualises form as strings of coded numbers. Her process is unlike that of other visual artists, although she is not alone in exploring the 'art of maths'. Phillipe Garenc, based in France, works with RhinoCAD and Autodesk 3ds Max and sometimes with FreeForm and Sculptris. There are many programs available for artists to use, some mentioned in Chapter 1 (see p. 9).

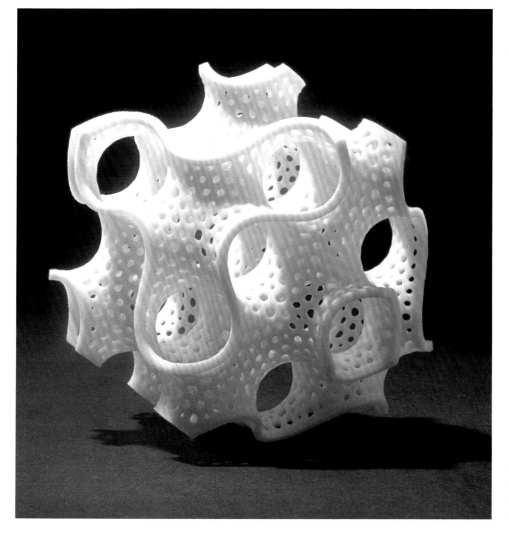

The vector file for the work, prior to processing by machine. *Photo: courtesy of Bathsheba Grossman.*

De-powdering *Gyroid*: the removal of the support material around the form when it is in its green (pre-fired) state. *Photo: Mike Shepherd, courtesy of The ExOne Co.*

Bathsheba Grossman, *Gyroid*, 2009. Soda-lime glass ballotini, 3D printed, 8.5 x 8.5 x 8.5 cm (3½ x 3½ x 3½ in.). *Photo: Bathsheba Grossman.*

Bowie the Bunny. Initial idea by Tara Reubsaet, 3D design by Rob Parthoens. *Photo: courtesy of Shapeways.*

THE EXONE CO.

The ExOne Co., based in Pennsylvania, has really been at the forefront of developing a glass-based process that has commercial viability and the ability to produce complex forms using the 3D printers they manufacture. Shapeways, based in the Netherlands and USA, uses ExOne Co. processes to work with artists in a variety of materials. This is what Glen Gardner from the ExOne Co. says about using the process to produce a flowered vase (see pp. 100–1):

Glass development here at the ExOne Co. began in the early spring of 2009. The first successfully printed and sintered parts were produced during this time. These were very small parts, all less than 40 x 60 mm, but the process proved viable. By summer of 2009 we had sourced and procured new materials and equipment to further this initiative. Parts up to 195 x 195 mm were now being successfully printed and sintered.

In October of 2009, I began my experiments for coating the raw sintered prints with glass paints and enamels. The enamelled vase [p. 101] ... was completed in December of 2009. This object was coated using a combination of lead-based clear and transparent coloured glass paints from Reusche. Because of the stigma and liabilities associated with lead-based materials, I was asked to find other materials for 'glazing' purposes. We finally settled on a clear zinc borosilicate flux to which mineral pigments may be added for colour effects. The colour palette is somewhat limited compared to the leaded material and the results will never be as juicy, but that has been a necessary trade-off for the company to produce glass parts for the public at large.

Z CORPORATION

Z Corporation is a commercial company that designs and builds 3DP equipment. Their machines are intended to print plastic-like materials, rather than glass. Recently, Z Corporation was purchased by 3DSystems, a publicly-traded company and by far the world's largest developer and supplier of 3DP equipment and services.

Z Corporation describes their process as: 'Plaster modelling that uses a cyanoacrylate or epoxy resin to add strength [when] using three-dimensional printing.' Their machines are in use within universities and research centres in the UK, in art and design facilities as well as in engineering. The process is multi-disciplinary, used across all areas of design and manufacturing. Z Corporation has worked across most sectors to help aid design and manufacture objects – from engineering, dentistry and the arts to shoes and mobiles.

Mark Ganter's process, developed using a Z Corporation machine and discussed on p. 103, uses amorphous (crushed glass) frit that has been pre-mixed with a sugar/starch binder agent. The Z Corporation machine's print head then applies an alcohol/water solution, which activates the sugar/starch binder and so holds the design object together.

ABOVE LEFT Printing the equidistant work: the red is the build-up of the glass form and the white is the support material. *Photo: Mark Ganter.*

ABOVE Printing multicoloured glass. *Photo: Mark Ganter, courtesy of Solheim Additive Manufacturing Laboratory at the University of Washington, Seattle.*

The ExOne Co. took these experiments further, and is now the only company providing actual 3D glass printing services to industry and the general public. The company's machines require the use of small-diameter glass beads (ballotini), but instead of pre-mixing a binding agent with the ballotini, a specialised 'polymer binder' is applied directly on to the powder bed to build and consolidate the design object. This might sound like a small detail, but it makes a huge difference in the final results of a glass print.

The Ganter/Z Corporation process allows the use of many commonly available coloured frits. Z Corporation machine systems are relatively inexpensive when compared to an ExOne machine system. Because of the cost of procuring custom-coloured ballotini, ExOne only prints with basic, clear glass media. However, the output of the ExOne system in regards to object size, dimensional accuracy, strength and surface condition produces dramatically different results.

Many other companies also make 3D printing equipment; please note that I do not advocate any one company over another.

What needs to be considered when 3D printing?

Many 3DP technologies are currently available which may be of use to glass artists. While it is possible to directly print objects made from glass, metal, plastics and ceramics, it must also be understood that, as yet, there is no single source or system that can provide all the potential needs of glass artists, as 3DP materials and processes remain in experimental modes. The actual use of non-commercialised materials and services will likely depend on one's ability to establish working links with private or university-funded research facilities. However, there are also many materials and service providers that are readily accessible to amateurs and professionals. Mostly all that is required is to provide a computer model saved in the STL format and a working budget.

Vase by ExOne Co. team in its green state (left) and after firing/sintering (right). This process is done using only one colour, with additional colour being added afterwards.

Photo: Mike Shepherd, courtesy of the ExOne Co.

By far the most accessible and least costly of 3DP systems and services are those that produce models directly in plastic media. Several of these materials are suitable for producing disposable patterns for use in investment casting moulds, similar to the lost wax process. Another application for plastic media would be for printing permanent patterns, from which refractory investment moulds could be cast.

Services and processes developed by the ExOne Co. are readily accessible to the public. These processes include direct printing in metal (3DMP) and in glass (3DGP). Metal prints consist of a 60–40 per cent composite of stainless steel and bronze. Metal models as large as 55 x 30 x 30 cm (21½ x 12 x 12 in.) are possible. This material could be suitable for permanent blow moulds. The cost of producing large metal prints is relatively high, but with careful design work, this process is competitive with traditional precision metal-casting services.

The ExOne Co.'s 3DGP process is similar to Mark Ganter's experimental 'vitraglyphic' printed glass process (p. 103). However, only the ExOne process is currently available as a commercial service. This process allows for some truly remarkable shapes and forms to be produced in soda-lime glass. In fact, some geometries, such as the work of Bathsheba Grossman, are likely to be impossible to produce by any other means.

3D printing of glass powder is really no different than printing any other powdered material. What sets this material apart from other media is that it requires a high-temperature thermal cycle to create a finished piece. As a glass print emerges from the print cycle, it is in a green state. It is little more than a stack of glass micro-beads temporarily held together by water-soluble binders. Green parts consist of approximately 56 percent glass; the rest is either air or binder. This is very similar to a traditional work of pâte de verre before firing (sintering). Depending on the sintering temperature, glass prints will shrink by around 20 percent. This is

Glen Gardener, *Vase*, 2009. 3D-printed,
hand-painted with Ruesche enamels,
17.8 x 7 x 7 cm (7 x 2¾ x 2¾ in.).
Photo: courtesy of the ExOne Co.

true of parts fired to 1000°C (1832°F). Below this temperature, shrinkage is less, but the final glass body tends to be weak and porous. At much above 1040°C (1904°F), the once-microscopic air bubbles begin to coalesce, forming larger bubbles that eventually break through to the surface of the final glass body.

The critical difference between 3DGP and traditional pâte de verre work is that, in order for this unorthodox process to work, there can be no rigid support mould. At 1000°C (1832°F), the soda-lime glass is quite fluid. To compensate for this movement (shrinkage), a refractory support media is required. Green prints are placed in crucibles and completely buried in a powdered refractory material. Hollow sections and overhanging elements all must be filled with support powder to prevent severe distortion or total collapse. Even with this support media in place, certain shapes will show distortion as the green print begins to consolidate. This is due to the nature of any liquid body, which always tend to pull to the centre of its mass. So, square sections or cubes will always show this phenomenon. While round sections or spheres also pull to the centre, the effect is symmetrical and not really detectable.

Hollow, vessel-like forms (like the vase shown on pp. 100–1) present special challenges. As these forms begin to sinter and shrink, pressure is exerted on the support media used to fill the form. To compensate for this and to prevent vessel walls from rupturing, small printed glass pellets are placed inside the vessel before sintering. These sacrificial pellets shrink at the same rate as the vessel and so serve as stress relievers.

Types of glass used

Many companies use soda-lime glass, which is recycled and relatively cheap. The glass is crushed to a particle size of approximately 50 microns. In the UK, companies such as Plowden and Thompson are able to provide powders in various sizes. A longer process is that of crushing glass manually and sieving it into various grain sizes. Mark Ganter at the Solheim Laboratory has used both Gaffer and Bullseye glass successfully. Whether you decide to crush glass yourself or use bought-in soda-lime grains, there will often be iron contamination. Before putting it into the machine, any iron needs to be separated from the glass powder using magnets.

Soda-lime is the cheapest glass powder to use for this process, but if you wish to apply colour, Bullseye or Gaffer glass are other options. There are differences between the methods used by the ExOne Co. and the Solheim Laboratory: the ExOne Co. can only take spherical powder, but Solheim can use amorphous granules, which allow for the use of colour. The shape and size of particles is important for the success of the outcome.

The ExOne Co. have kindly allowed me to show process photographs from their company: p. 97 shows a work being de-powdered and pp. 100–1 show the three stages of form development: green state, fired state and with enamels added. They are major producers of 3D printing and at the forefront of developing the processes applied by Shapeways. Both Mark Ganter and the ExOne Co. have helped move the process of 3D printing to a level at which artists can easily apply it to their work.

Access to services

In the last three years, it has become easier to liaise with companies using rapid prototyping and 3D printing techniques. Companies such as Alpha Prototypes, the ExOne Co. and Shapeways are seeing demand multiply every year, as well as interest in extending the capabilities of the process through requests to use it with different types of materials. You can work with these companies remotely, by sending them an STL file online; the item is then returned in the post. Most sites that offer this service provide a guide to what to do in terms of making the digital file. The other way is to find a local company and build up a dialogue.

If you are looking to build a wax composition from which a mould can be taken, there are companies who offer this service via the same process. The new process of sintering glass into an object without having to work first with wax or other materials also offers new potential. However, size is currently a limiting factor.

The processes are ideal for the production of items being used in multiples and where the outcome requires a particular finish. You could seek out universities with research facilities that offer commercial activity, such as Swansea Metropolitan University. The size and scale of work will be limited by the bed size of their machine. Companies such CRDM in High Wycombe are able to offer a variety of processes and work to greater tolerances and a larger scale. Both use either SLR or SLA, which are expensive processes, so much depends on your budget.

New developments in 3D printing

This process is challenging what we can do with glass, especially with the possibility that small desktop printers will become available for the design studio. Although it is still expensive for glass artists, the new possibilities opened up by the process have been evidenced by the work of various makers as they experiment.

MARK GANTER'S 'VITRAGLYPHIC' 3D PRINTING

The Solheim Additive Manufacturing Laboratory at the University of Washington, Seattle, led by Professor Mark Ganter (whose glass objects are in gallery and museum collections and discussed in journals such as *Glass Review*) and commercial company the ExOne Co. are exploring methods of creating a 'digital pâte-de-verre' or lost wax casting process, using glass powder directly. Glass grains are fed through the 3D printer, using an organic binder to retain the shape – a process that Mark Ganter has labelled 'vitraglyphic'. The form that is produced has a matt, rough surface that has little transparency. The Solheim lab is also looking at methods of producing moulds by 3D printing, in which glass billets can be cast, allowing transparent glass objects to be produced. Charlie Wyman and Grant Marchelli have been helping to investigate this process.

Grant describes the process of creating glass forms as follows. He initially scans an object with a touch probe scanner to generate a mesh shell, which is then

Mark Ganter, *Vitraglyphic Rendering of Enneper's Minimal Surface*, 2010. Vitraglyphic glass, 7.6 x 7.6 x 6.3 cm (3 x 3 x 2½ in.). *Photo: Mark Ganter.*

Mark Ganter, *South-Western Pots*, 2009. 3D-printed potter's clay. *Photo: Mark Ganter.*

modified in RhinoCAD and exported as an STL file. The file is then transferred into the system to be printed. Once printed, the form is in a 'green' or unfired state. It is then transferred to a kiln for firing. Currently, Grant keeps the firing temperature quite low so as to not distort the form too much; however, there has been shrinkage in some of the forms. (There is still more potential in this process: as many glass artists know, the temperature at which pieces are fired will affect the results.) At the moment they are using industrial sapphire to contain the form; you would not want to put a wet plaster mould around a green-state form as the moisture would seep into it. A green-state form is like a sponge and will absorb liquid and hold on to it. In another project, Grant has developed this sponge-like quality to produce glass bricks that plants can grow on, for the manufacture

ABOVE LEFT 3D-printed mould
produced at Falmouth. *Photo: courtesy
of Tavs Jorgensen and Gayle Matthias,
University College Falmouth*.

ABOVE CENTRE Glass outcome from
the mould produced at Falmouth.
*Photo: courtesy of Tavs Jorgensen and Gayle
Matthias, University College Falmouth.*

ABOVE RIGHT Skull cast in a 3D mould.
The mould has been produced using
3D printing. *Photo: courtesy of Charlie
Wyman, design by Grant Marchelli.*

LEFT Charlie Wyman, *First Snow*, 2010.
Kiln-formed glass cast in 3D-printed
moulds. *Photo: Charlie Wyman.*

of 'living' walls. As for software, Mark works with a range of platforms, such as
Mathematica, RhinoCAD, Grasshopper and SolidWorks – anything that will
allow an STL file to be produced.

When using the vitraglyphic process, the size and distribution of the glass
particles is important. The binder is a mixture of water and alcohol and the adhesive
that is mixed into the powder is a combination of very fine sugar and maltodextrin
(a food additive, easily dissolvable). Gum arabic might also work, as long as the
green-state body was able to accept the compound and have water sprayed on it to
dissolve it. Whatever is used needs to dissolve in the power without any residue.

Other artists are investigating a more diverse approach to the way that the
process is applied, either through direct glass printing or via indirect methods to

ABOVE LEFT De-powdering Phillippe Garenc's *Vitruvius*. This is a great example of de-powdering an ExOne 'build box'. The newly-emerging glass prints are buff coloured due to the thermal cure cycle that sets and toughens the polymer binder. These prints sit on top of the residual glass media (the powder bed), which has served to support the objects during the build process. This residual media can now be recycled for future use.
Photo: courtesy of the ExOne Co.

ABOVE RIGHT Philippe Garenc, *Vitruvius*, 2010. This photo illustrates the less than perfect results after sintering a model. Some warpage and distortion is present in the lower left side of the object. Some geometries are very difficult to sinter successfully. 3DGP designs with hard angles and square sections show more distortion than organic, flowing designs and designs with isolated hollow sections are difficult to support during the sintering process. Unfortunately this design contains both problematic elements. Over six attempts were required to get one near-perfect model. Printed by the ExOne Co. via ExOne 3DGP technology, in selective sintering with ballotini glass beads.
Photo: Glen Gardner, courtesy of the ExOne Co.

produce glass forms. Two photos on the previous page show a collaborative project between the glass artist and lecturer Gayle Matthias and designer Tavs Jorgensen, a research fellow with Autonomatic at University College Falmouth. They have been looking at methods of production for glass casting using a Z Corporation machine.

MANUFACTURING MOULDS FOR CASTING

University College Falmouth and the Solheim Laboratory have been investigating the use of 3D printing to make moulds that are strong enough for casting. At Solheim, they are working with VOHP ('version out of the bag' Hydroperm) to manufacture moulds. Hydroperm is a ready-made plaster mix for casting; they simply open the bag and tip it into the machine. Solheim are looking to expand the systems and recipes available to manufacture moulds for complex casting, investigating materials that are easily available to artists working in both glass and ceramics.

Mark Ganter has been collaborating with the sculptor Laura West in trying out various types of ready-made mixes. They found that the Hydroperm mix could be left dry and had a good 'green' strength; adding water afterwards, through spraying or light washing, made the mould even stronger. The mould was then air-dried or heat-dried.

Artists such as Geoffrey Mann are developing techniques using the process, for example in the manufacture of his bird-in-flight glass casting. The rendered form was used to produce the wax model from which a mould was made. Geoffrey displays a real understanding of how to mix technology and form to capture what he wishes to create. The figures opposite show the scale at which he works, which is far larger than that of most artists working in glass. In work of this magnitude the high production costs are valid, as the process is probably the only method that will achieve his required outcome. The wax models go to Lhotský's glass studio in the Czech Republic for the manufacture of the final form.

Michael Eden is another artist who has used 3D printing for ceramics. He has undertaken some initial experiments in glass to manufacture a mould, using ballotini beads to manufacture the glass form. Philippe Garenc, an artist based in France, has also used the 3D printing process with ballotini to produce work.

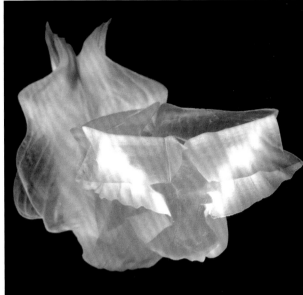

ABOVE LEFT A rapid-prototyped form created on a Z Corporation machine. *Photo: courtesy of Geoffrey Mann.*

ABOVE RIGHT Geoffrey Mann, *Flight Landing*, 2005. Cast glass, 65 x 40 x 35 cm (25½ x 15¾ x 13¾ in.). *Photo: Sylvain Deleu, courtesy of Geoffrey Mann.*

RIGHT Wax form for another piece, *Flight Take-Off*. *Photo: courtesy of Geoffrey Mann.*

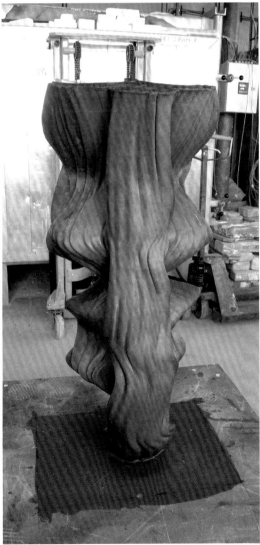

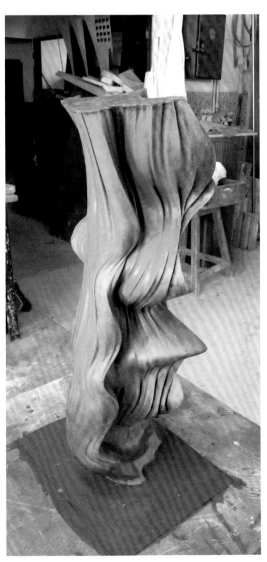

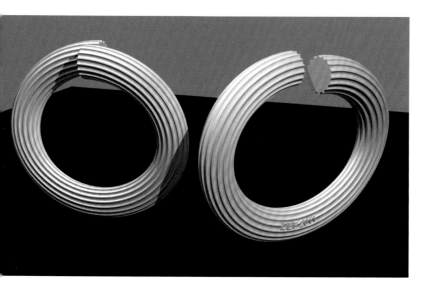

ABOVE LEFT Digital render of the jewellery design. *Photo: courtesy of Donald Friedlich.*

ABOVE RIGHT Donald Friedlich, *Column Series Brooch*, 2011. Produced using 3D printing, glass and 14-carat gold, 7.5 x 7.5 x 2 cm (3 x 3 x ¾ in.). *Photo: Donald Friedlich.*

SHAPEWAYS

Companies such as Shapeways (USA and the Netherlands) are offering a whole package of services for any person interested in designing and selling 3D-printed objects. As previously mentioned, you can send them your file and they will process it into a 3D form and post it back to you. They offer a whole range of materials such as glass, wood, silver and wax. The other interesting development on the commercial side is that this company offers a selling gallery so that, if you wish, the product can be sold through their website.

Pete Weijmarshausen, the CEO of Shapeways, is hoping that before long they might be able to produce crystal-clear glass items using the 3D printing process. This may take some time: as many glass workers know, when using such small granules, the possibilities for crystal clarity are limited. The machines they use currently have a size limitation, so production is limited to small, hand-sized objects (7.5 x 7.5 x 5 cm, or 3 x 2 x 2 in.), more suited to jewellery and small multiple applications.

Artists from around the world are using the site for the manufacture of work and in its capacity as a gallery for promotion. Donald Friedlich is one jeweller who uses a variety of processes and has a vast skill set. He has used Shapeways' service to produce a piece of work that exploits the process beautifully – see the figures below. For Philippe Garenc, who collaborates with Ergastule and teaches at CERFAV (Centre Européen de Recherches et de Formation aux Arts Verriers), it is just another extension of his practice.

STEVE ROYSTON BROWN

This technology can be applied in a much more basic way. Steve Royston Brown might describe his working method as 'low-budget 3D printing done in the backyard studio'. He has a background in printing and has developed a method whereby he applies screen-printing processes and meshes as a way of building up forms using

LEFT Layering of powders to print *Hive*. *Photo: Steve Royston Brown.*

BELOW LEFT Kiln set-up for *Hive*. *Photo: Steve Royston Brown.*

BELOW CENTRE De-powdering the work. *Photo: Steve Royston Brown.*

BELOW RIGHT Steve Royston Brown, *Hive II*, 2010. Kiln-formed glass, 29 x 29 x 4 cm (11½ x 11½ x 1½ in.). *Photo: Steve Royston Brown.*

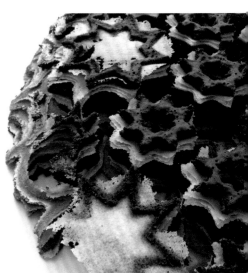

glass powders/frits. He uses a multitude of techniques, from the technological through to those that are easy to apply within the artist's studio. The figures above demonstrate that most processes can be simplified to work within a studio.

The future

I do not think it will be too long before multiple-colour 3D printing using glass powders is possible. Experimentation within companies and universities will no doubt eventuate in the ability to easily produce complex geometries and internal voids, forms that sit inside one another, and forms with undercuts, which traditional methods of glass-making find difficult. Indeed, creating these forms using 3D printing has in some cases already become a reality.

I can also see the process being using for the manufacture of two-part metal sintered moulds for glass-blowing. Remember that with these additive processes, the forms are often stronger than the original material they have been made from.

6

Vinyl plotting

A vinyl plotter is a machine that cuts a design from vinyl and is used by industries such as sign-making and vehicle livery, among others. Most artists who work in glass have memories of spending hours drawing by hand before hand-cutting vinyl or Fablon with a scalpel, and trying not to score or scratch the surface of the glass when using vinyl for stencils or resists.

Now, especially with the demand for multiples and bigger works, using a plotter machine for this process may be very helpful, as it allows designs to be larger in scale, and cuts vinyl more efficiently than is possible by hand. Something that may have taken days to cut out by hand can instead be cut in the space of an afternoon.

A very different application of the plotter is to use it with a drawing tool, to draw a scaled design onto paper. Artists do this to see how the work will look at the planned or required scale.

Vinyl plotting.
Photo: Steve Royston Brown.

Applications of vinyl plotting

Vinyl plotters are now used in various companies, university departments and artists' studios. Many artists have found the vinyl plotter to be a useful tool and small plotters are available at an affordable price.

Vinyl is useful for the following processes in glasswork:

1. As a resist for sandblasting and acid etching.

2. As a resist for airbrushing enamels, screen-printing and gilding; masking areas for painting and silvering.

3. Direct application – some artists use vinyl directly with glass, as part of the design, instead of just using it to facilitate methods of working with glass. In direct application, the process is cold. No heat or kiln work is required, just the smooth application of the vinyl on to the glass surface (ideal for designs with a limited budget or for temporary locations).

Vinyl-plotting machine.
Photo: Vanessa Cutler.

How does a vinyl plotter work?

As with most of the processes in this book, the plotter uses a digital drawing or scanned image. This process can be handled in one of three ways:

1. A hand-drawing or photograph is scanned and input into the drawing software (e.g. Illustrator), then exported in a file type suitable for CAD software. In the CAD software, the image is converted into a vector. This is put into CAD/CAM software such as IGEMS for nesting and converting to CNC code, and the plotter interprets the code to do the cutting.

2. Working directly in the drawing software, an image is created for the vinyl plotter. Again, it is converted into a vector. Then the vector is input into the CAD/CAM software, which converts it to CNC code, and the plotter does the cutting.

3. A file from Illustrator or a raster file may be sent directly to the plotter, with no interfacing software needed to convert it to CNC code. The machine is able to interpret the file exported from Illustrator and do the cutting.

ABOVE **Designing a form for vinyl plotting.**
Photo: Vanessa Cutler.

BELOW **Smoothing out images (removing additional vector points, making the images look less angular) in Illustrator for vinyl plotting.** *Photo: Vanessa Cutler.*

The three methods may seem very similar, but different plotters require different methods, depending on their capabilities. Some are geared to the type of company buying their product (software such as MasonART is aimed at stonemasons producing memorials and headstones and can make vectored images for the vinyl plotter). Others have no interface (no secondary CAD/CAM software, as in option 3) and for those artists working directly from home or the studio, this is probably a good option (see Caroline Rees' decision-making process on p. 115).

Vinyl plotters work on an x-axis and y-axis, travelling left to right and top to bottom. The vinyl is fed through on rollers, allowing the cutting blade to glide through the vinyl sheet. During the initial set-up, the blade is programmed to cut material up to 3 mm thick.

RIGHT **Vinyl being cut.**
Photo: Recognition Express Southern.

Weeding out the form (that is, removing the waste vinyl so that you are left with the vinyl template).
Photo: Recognition Express Southern.

Using a vinyl-plotting company

Vinyl is a by-product of PVC (polyvinyl chloride). Commercial firms use vinyl that comes in rolls backed by adhesive, in a variety of widths from 50–160 cm (19¾–63 in.). I asked one vinyl-plotting company what would be required if I wanted to have work cut and I have included their response below.

Q: Does your system have its own software?
A: Our plotter has a software driver, so we can just send the artwork to 'Print' using a graphics package like CorelDRAW. Large-format printers do have their own software (for print and cut, not design) known as RIP.
Q: Which files do you ask clients to send?
A: Plotters will only recognise vectored graphics, so an EPS file is the best format, not that our customers ever supply it! We normally draw it all in-house.

Note this format is particular to one company; different types of files may be required. If you know what a company expects and which file types they prefer, it helps to reduce the amount of preparatory work that they may need to carry out. This will also lower the cost to you. Every company will have preferred software, but supplying an initial drawing in Illustrator is a good starting point.

Using vinyl plotting in glasswork

Vinyl plotting has been used by many artists around the world to create stencils and resists for the deep carving of glass, as well as for other processes mentioned previously. Artists such as Lawrence Morrell, David A. Smith and Caroline Rees work in quite different ways on glass, but all are using vinyl plotting because it offers the ability to replicate their drawings on a larger scale. It is also economical, as it reduces the amount of time spent having to cut stencils by hand.

LAWRENCE MORRELL

Lawrence has used vinyl for a number of years in the process of creating large commissions and small, intricate works. His 2010 fine art sculpture, the pink *Gem Heat*, was created using sandblasting over a vinyl resist, which was plotter-cut from an image of the heat signature of the surface of a ruby, at a temperature of over 537°C (1000°F). It is the first of a series of glassworks that involve deep carving and filling with colour, then slumping and fusing together to create layers. There are also plotter-cut images embedded in the glass, making up a very complex piece of work. He has vinyl-plotted images on to several layers before sandblasting them and placing them in the kiln. Those sandblasted images are then encapsulated in the glass, as seen in *Gem Heat* (below).

ABOVE Lawrence Morrell, external glass façade, 1980s. The external façade was a collaborative piece with other artists in New York. The application was sandblasting; vinyl plotting was used to produce a resist over a very large surface area too big to be done by hand. The plotter helped to reduce the time spent cutting by hand and allowed the artist to control the depth to which he wanted to go. *Photo: Lawrence Morrell.*

LEFT Lawrence Morrell, *Gem Heat*, 2010. Carved glass, 27 x 21.5 x 4 cm (10½ x 8½ x 1½ in.). *Photo: Lawrence Morrell.*

Lawrence Morrell,
Staircase, 2008. Sand
carving and fibre optics.
Photo: Lawrence Morrell.

CAROLINE REES

Caroline Rees combines the use of hand-drawn and hand-cut stencils with vinyl-plotted stencils. Often, the scale of the work and complexity of design can be the reason for using the vinyl plotter. Her approach is still very much about capturing the hand-drawn element – to her this is crucial and makes her work stand out.

Over the past decade, she has worked directly with her own vinyl plotter for small commissions and also with commercial companies such as Proto Studios, to which she might subcontract larger works. Unlike many artists who use software such as Illustrator directly, she develops her ideas by drawing on paper and then scanning this into the computer. She can then manipulate the images to actual scale. She finds that quality is lost when drawing directly into a software program and scaling the line. As she has stated: '[In] trying to create the hand-drawn quality ... with technology, it's very difficult to scale up just in Illustrator as you lose certain qualities; the essence of the work is to capture the hand-drawn.'

All the initial design process work is done by Caroline during the design stage: this will include working out the depth levels for sandblasting, from shallow to carved, prior to the design being sent away. Through her experience in sandblasting, she already has an idea of how layers of sandblasting will work in her designs. She has built up a strong communication with the companies she uses to get her work manufactured, so they understand the finish she requires. She sees the handover to the company as the time to stop working – artists can always keep tweaking, but this doesn't make good sense commercially. Caroline may visit during manufacture, but tries not to get too involved, although it has been known for her to add lines or cut out smaller details if required.

For her own vinyl plotter, Caroline decided on one that uses a USB connection from computer to plotter and which has no 'middle' or transition CAD/CAM software. (With many techniques mentioned in this book, a transition program is required: for example, for the water-jet machine, the software IGEMS determines 'nesting' and produces the code to be read by the machine.) Caroline's plotter reads directly from Illustrator: there is no middle program to learn, so it is less work for her. Alongside the plotter, she may also use hand tools to help add to the variation of line.

Caroline Rees, *Urban* (detail), July 2011. Sandblasting with deep carving, 6 mm float glass, 50 x 20 cm (19¾ x 8 in.). *Photo: Caroline Rees.*

ABOVE Caroline Rees, *Windsor Screen*, commission for medical centre, June 2010. Sandblasting with deep carving, 12 mm glass. Imagery is derived from the locality of Windsor, engaging and distracting waiting patients, 13 x 2.4 m (42 ft 8 in. x 7 ft 10½ in.). Dedworth Medical Centre, Windsor. *Photo: Caroline Rees.*

RIGHT Caroline Rees, *Panel*, 2005. Sandblasted 8 mm float glass, 170 x 35 cm (67 x 13¾ in.).
Photo: Graham Matthews.

Glass sign by David Adrian Smith. Gold-leaf, mother-of-pearl inlay, matt gilded centres with acid etching. Vinyl was used for masking the acid, 91.5 x 61 cm (36 x 24 in.).
Photo: courtesy of the artist.

Working on a glass sign.
Photo: courtesy of the artist.

DAVID A. SMITH

David Adrian Smith is a signwriter who specialises in brilliant cutting and all the techniques associated with Victorian glasswork, such as reverse painting and staining, and uses materials such as vinyl to act as a resist in some of his applications. He draws intricate scrolling by hand and transfers them into vectored drawings to enable them to be cut by a vinyl plotter. He combines technical and traditional processes to help aid manufacture: as with many artists, he cites timescales and accuracy as reasons for using vinyl plotting.

PROTO STUDIOS AND CHARTERBROOK SIGNS

Proto Studios in Pewsey, Wiltshire, specialises in the manufacture of glass for artists who are commissioned to produce large, site-specific, architectural glassworks. The ability to scale and replicate an artist's designs is a very important element of the collaboration between artist and studio and having vinyl-plotting equipment does help.

Proto Studios screen-prints and sandblasts commercial-sized pieces of glass. Because the scale of the projects they undertake is large, hand-cutting vinyl would be something of a costly process for them; hence the use of vinyl-plotting equipment.

Commercial companies such as Charterbrook Signs in Swansea are able to cut and prepare vinyl to a variety of scales using the images submitted to them. These companies offer services ranging from the production of banners, posters and badges to vehicle livery. They have a variety of resists and vinyls available and can offer advice to artists on which will be suitable once they understand what needs to be achieved. Unlike most of the processes discussed in this book, vinyl – either being cut for you or by you – can be very cost-effective and affordable.

CHRISTIAN RYAN

Christian Ryan is an architectural glass artist who has been using a variety of processes within his work, including vinyl plotting. He has used vinyl both as a resist for sandblasting and for airbrushing enamels on to glass. Christian finds the vinyl plotter to be ideal for achieving accuracy in lettering.

ABOVE AND RIGHT Christian Ryan creates a commemorative plaque for Archbishop McGrath Catholic High School, 2011. Both photos show the cleaning and removal of the vinyl after the glass has been sandblasted. *Photo: Rod Jones.*

LEFT Christian Ryan, *In The Blink Of An Eye I*, 2010. Reverse painting on low-iron glass, overall dimensions 122 x 122 cm (48 x 48 in.).
Photo: courtesy of Christian Ryan.

ABOVE Christian Ryan, *In The Blink Of An Eye III*, 2010. Reverse painting on low-iron glass, overall dimensions 122 x 122 cm (48 x 48 in.).
Photo: courtesy of Christian Ryan.

DEBRA RUZINSKY

Debra Ruzinsky, who is based in America, started using vinyl plotting in the early stages of her practice, from which she developed an interest in other technologies such as CNC routing and laser cutting, which her current cast glasswork utilises. She explains:

I earned my bachelor's degree studying Design at UCLA in Los Angeles, California. Really, however, I was trained to be an artist using craft media. From that time I have always straddled two fields – design and fine art. Technology has been a link for me between these two parallel paths.

When I started a production glass studio called Ruzinsky Glass, I made picture frames, mirrors, tables and custom pieces for the home. Technology allowed me to streamline the making of a primarily hand-made product line and gave me the freedom to expand the possibilities of the work I could produce. I learned how to use a computer and software for drawing Bézier curve artwork, for output to a vinyl cutter made for the sign-making industry. This gave me the tools to produce vinyl resists for sandblasting glass. I used this process to design and produce objects with repeatable surface

decoration. This formed the basic technique around which I designed the entire product line. The technology gave me the skills to design and produce custom architectural glass, graphics and signage for films, commercials and theme parks. For 11 years, I worked for Walt Disney Imagineering, building upon the computer skills I [had] developed in my studio work.

Later, after going back to school at the Rochester Institute of Technology to earn my Master of Fine Arts in Glass Sculpture, I applied these same basic techniques for the machining of materials on a computer-controlled router (CNC). I used the computer to draw 2D shapes, cut them out on the router, stack them and glue them together. At first this allowed me to make elaborate 3D base pieces for my cast glasswork. Now I am further employing this technique to produce patterns for making rubber and refractory moulds. I translate the hard-edged look of a form cut by computer by using that form to make moulds for casting glass. The technology opens up a whole world of possibilities, broadening what I can imagine, expanding what I can produce.

Early works such as *Aim True* and *Cafe Parsons Table* were made from flat glass using computer-cut vinyl as a sandblasting resist to create the surface decoration. Hand-painting techniques were used in combination with the vinyl resist. Debra used design software to draw the Bézier curve line art and text, which was then converted into vector paths in Illustrator before being cut on Gerber and Roland plotters.

Debra Ruzinsky, *Tables*, 1992. Sandblasted glass painted with lacquer, enamel and bronze powders, on wrought iron bases. Glass tabletops created with computer-cut resists for sandblasting and painting, made with vinyl-plotting technology. Sizes range from 33 x 45 cm (13 x 17¾ in.) to 55 x 65 cm (21½ x 25½ in.).
Photo: Debra Ruzinsky.

Costs

The cost of a small plotter for the studio starts at around £1,000. If, like some of the artists mentioned, your work is utilising techniques such as sandblasting regularly, it may be a wise investment.

Often, plotters come with a long list of what they can do, much of which will not necessarily be relevant to you. Search websites and visit companies to see what is most suitable. Get a demonstration and ask lots of questions to develop an understanding of what each machine offers. Also consider the other costs involved, such as buying vinyl and cutting blades. Find out whether blades can be changed easily and the type of vinyl and images that a machine can cut. Sometimes a machine may be more suited to lettering than fluid, hand-drawn line work. Most of all, a machine needs to be easy to understand and operate, to allow you to find a way of working that is beneficial and time-efficient.

On the other hand, if you are going to approach a commercial company to have stencils or resists cut, you will find that most will charge an initial set-up cost, and then depending on the time required for programming and cutting, along with the type of vinyl being cut, the price will vary. Having vinyl cut for you is very cost-effective, especially if you are working in multiples and need to replicate an image. It can also be done quite quickly.

ABOVE LEFT Debra Ruzinsky, *Sweet Distraction*, 2008. Kiln-cast glass and lead crystal with CNC-routed MDF base, 92 x 92 x 120 cm (36¼ x 36¼ x 47¼ in.). *Photo: Elizabeth Lamark, ETC Photo, Rochester, New York, USA.*

ABOVE RIGHT Debra Ruzinsky, *Photo frames*, 1991. Bevelled, sandblasted and painted glass, assorted sizes, made with resists created using vinyl-plotting technology. *Photo: Debra Ruzinsky.*

Conclusion

The aim of this book was to show that glass artists today are using a variety of processes to create their work and that these processes are often making effective use of new and developing technologies. Sometimes this use is noticeable, and at other times not, but what everyone has in common is a thirst for knowledge and a drive to develop their own practices.

Much of this technology has been available in different working spheres for years and you might have thought that it would overlap with the world of glass before now. The materials we use in our studios are many and varied and often we need to draw on industry to help in using those materials to their full potential. There are many times that I have wished that I had my father's engineering lathe in the garage in order to be able to mill steel!

By building relationships with industry within our own specialism, and those of other sectors, we start to learn what is available to develop for use with glass. Often, collaborations between artists and industry can lead to a lifetime of conversation, mad experiments and a body of work that reflects that journey. We ride on the coat-tails of engineers, who start with an idea and produce a new outcome – and then we come along, asking questions and trying to push the boundaries. Sometimes this can upset the balance of things as they are, but these challenges and disturbances can also generate new creative methodologies, which can be recycled back into commercial activity. The relationship is, in this way, symbiotic.

What will be the role of technology in working with glass over the next ten years? My belief is that it will be where it has always been – sitting comfortably alongside those traditional skills that glass artists have always employed. The types of glass we use may become more technical and the geometries more complex, with digital imagery and coatings that have come straight out of a laboratory, but primarily it will all be down to the glass artist's individual journey.

Kirsteen Aubrey, *Icicle
Garden*, 2011. Sub-surface-
laser-engraved glass,
8 x 5 x 5 cm (3¼ x 2 x 2 in.).
Photo: courtesy of Tony Richards.

Suppliers

1 Digital tools

SOFTWARE

AutoCAD
www.autodesk.com

CorelDRAW
www.coral.com

Google Sketch Up
www.sketchup.google.com

Grasshopper
www.grasshopper3d.com

IGEMS
www.igems.se

Illustrator
www.adobe.com

Lantek
www.lanteksms.com

Mastercam
www.mastercam.com

RhinoCAD
www.rhino3d.com

Solidworks
www.solidworks.com

Tridimensional
www.tridimensional.com

COMPANIES

Established & Sons
www.estalblished&sons.com

Haystack
www.haystack-mtn.org

Manchester Fab Lab
www.fablabmanchester.org

MIT Centre for Bits and Atoms
www.cba.mit.edu

ARTISTS

Kirsteen Aubrey
http://www.artdes.mmu.ac.uk/profile/
kaubrey/research

Michael Eden
www.edenceramics.co.uk

Thomas Heatherwick
www.heatherwick.com

Tavs Jorgensen
www.oktavius.com

Jessamy Kelly
www.jessamykellyglass.com

Aimee Sones
www.aieesones.com

Marcel Wanders
www.marcelwanders.com

2 Water jet

COMPANIES

Creative Edge Master Shop, USA
www.cecwaterjet.com

Flow
www.flowwaterjet.com

KMT Waterjet
www.kmtwaterjet.com

OMAX
www.omax.com

Water Jet Sweden
www.waterjetsweden.co.uk
www.waterjetsweden.se

RESEARCH CENTRES

The Creative Industries Research and
Innovation Centre (CIRIC), Swansea
Metropolitan University
www.smu.ac.uk

Institute of Sustainable Design
(ISD), Faculty of Applied Design and
Engineering, Swansea Metropolitan
University
www.isdwales.com

MIRIAD Craft Research Centre,
Manchester Metropolitan University
Contact Prof. Stephen Dixon

Sunderland University
www.sunderland.ac.uk

University of Nottingham, Rolls-Royce
University Technology Centre
www.nottingham.ac.uk/~epzutc/

Metropolitan Works
www.metropolitanworks.org

ARTISTS

Esther Adesigbin
www.estheradesigbin.com

Chris Bird-Jones
www.birdjonesandheald.com

Brian Boldon
www.brianboldon.com

Thierry Bontridder
www.bontridder.eu

Jon Chapman
www.jon-chapman.com

Scott Chaseling
scottchaseling.tumblr.com

Jacqueline Cooley
www.jacquelinecooley.com

Vanessa Cutler
www.vanessacutler.co.uk

Erin Dickson
www.erindickson.carbonmade.com

Rachel Elliott
www.rachel-elliott.com

Rena Holford
www.hagghillglass.co.uk

Catrin Jones
www.catrinjones.co.uk

Robert Knottenbelt
www.robknottenbelt.com

James Maskrey
www.sunderland.ac.uk/faculties/adm/
research/artanddesign/researchstaff/
jamesmaskrey

Inge Panneels
www.idagos.co.uk

Jeffrey Sarmiento
www.jeffreysarmiento.co.uk

Blanche Tilden
www.blanchetilden.com.au

Margareth Troli
www.cgs.org.uk

3 Laser-cutting and engraving

COMPANIES

Haven Laser Engraving
www.havenlaser.com

Knowlton School of Architecture
fab lab
www.ksacommunity.osu.edu/group/
digital-fabrication-lab

MDI Schott
www.mdischott-ap.de

Ohio State University
www.osu.edu

Schott
www.schott.com

Vitrics
www.vitrics.com

ARTISTS

Kirsteen Aubrey
http://www.artdes.mmu.ac.uk/profile/
kaubrey/research

Kane Cali
www.kanecali.com

Annie Cattrell
www.anniecattrell.com

Bathsheba Grossman
www.bathsheba.com

Arik Levy
www.ariklevy.fr

Geoffrey Mann
www.mrmann.co.uk

Christopher Pearson
www.christopherpearson.com

4 Multi-axis machining

COMPANIES

Advanced Glass Technologies
www.agt-int.com

ARTISTS

Shelley Doolan
www.shelleydoolan.com

David Edwick
www.davidedwicksculpture.co.uk

Donald Friedlich
www.donaldfriedlich.com

Christopher Ries
www.christopherries.com

Zak Timan
www.zaktiman.com

Richard Whiteley
www.richardwhiteley.com

5 Rapid prototyping

COMPANIES

Alpha Prototypes
www.alphaprototypes.com

CERFAV
www.cerfav.fr

CRDM
www.crdm.co.uk

The ExOne Co.
www.exone.com

Lhotsky Studios
www.lhotsky.com

Justin Drummond
www.air.falmouth.ac.uk/research-
groups/autonomatic

Shapeways
www.shapeways.com

Z Corporation
www.zcorp.com

ARTISTS

Charlie Wyman
Contact via University of Washington

Professor Mark Ganter
www.open3dp.me.washington.edu
www.me.washington.edu/people/
faculty/ganter/

Phillippe Garenc
www.garenc.com

Steve Royston Brown
www.steveroystonbrown.com

6 Vinyl plotting

COMPANIES

Charterbrook Signs
www.charterbrook.co.uk

Recognition Express Southern
www.re-southern.co.uk

Proto Studios
www.protostudios.com

Rochester Institute of Technology
www.rit.edu

ARTISTS

Lawrence Morrell
www.lawrencemorrell.com

Caroline Rees
www.blastedglass.co.uk

Debra Ruzinsky
www.debraruzinsky.com

Christian Ryan
www.christianryan.com

David A. Smith
www.davidadriansmith.com

Glossary

3D modelling software: Computer software that allows the drawing of three-dimensional forms.

3D printing: A method of additive engineering using inkjet technology to produce three-dimensional forms.

abrasive water-jet: High-pressure water-jet machine, using water and an added abrasive, such as garnet, for cutting a variety of materials.

additive engineering: A term for the processes of rapid prototyping.

axis: Line of rotation – for example, movement on x-axis = left to right, y-axis = forwards and backwards, z-axis = up and down.

ballotini: Spherical glass beads or balls used in the pâte-de-verre process. Also used in the manufacture of paint used for road markings.

Bézier curve: A parametric curve frequently seen in computer graphics, especially in the manufacture of vectorised forms.

borosilicate: A type of glass that has a low coefficient of expansion, comprising silica and boron oxide, and first developed by the glass company Schott.

Bullseye glass: A brand of compatible fusing glass from Portland, Oregon, USA.

CAD/CAM: Computer-aided design/computer-aided manufacture.

carbide wheels: Glass-cutting wheels used for the manual cutting of glass. The cutting head is made of tungsten carbide.

CNC: Computer numerical control; the term for the coding used by the machines.

cyanoacrylate: A type of fast-acting binder used in the manufacture of forms in 3D printing – an 'instant glue', like super glue.

Dremmel: A brand of engraving tool used for various materials. Along with small diamond-coated tools, it can be used for engraving and surface abrading glass.

DWG: A file format (vector file).

DXF: A file format (vector file).

Fablon: Type of sticky-back plastic used by glass artists for sandblasting.

FARO scanning: Three-dimensional scanning of forms which can't be easily identified or captured (more ephemeral forms). FARO is a brand of scanner.

formers: Moulds or supports made from various materials (often steel), over which glass can melt.

functional MRI: Magnetic resonance imaging, used to capture internal structures, particularly used within the medical industry.

fusing: The melting together of multiple glass surfaces, between a heat of 650–850°C (1202–1562°F).

garnet: Type of abrasive used by water-jet machines.

grade mesh: The standard sizes of grit, which work up through various grades, 60-mesh being very coarse and 1200-mesh being very fine.

grozing tools: Pliers used to nibble away the edges of glass. Used in the practice of glass-cutting, especially stained glass, and by artists using kiln-forming techniques.

green-state form: An unfired form.

JPG: Graphic file made up of pixels.

kerf: The angle of a cut on glass.

kiln-forming: Processes for treating glass that are carried out in a kiln, including techniques such as fusing, slumping and casting.

micro-flaws: Microscopic fissures or breaks in the material's surface.

micro-scribe: A digital tool that is used to capture movement and the physical properties of three-dimensional objects.

milling: Surface abrasion used either to create a form or create a textured surface.

moulds: A negative form into which glass is able to melt or fuse together into a desired form. Made from a variety of materials including plaster, wood, metal or graphite.

multi-axis: Many angles of rotation (axes), not just an x-, y- or z-axis.

murrine: Italian word for small tiles of patterned glass, as made by the Venetian glass-makers.

nesting: The placing of the shape or part to be cut from the sheet material, which is done in CAD/CAM software and enables CNC code to be generated.

olivine: Type of abrasive used by a water-jet machine, often used by firms cutting glass.

orifice: Another term for the aperture of a water-jet nozzle.

polymer binder: A plastic-based mix that can offer strength and support to the composition of an object or form, applied after 3D-printing. The glass surface takes on a slightly plastic finish.

pin-mould former: A mould made out of movable pins with adaptable heights.

PSI: Pressure per square inch.

reconfigurable tooling: Flexible digital design that minimises the need for traditional tooling methods, using software such as CAD/CAM to prototype and reduce tooling costs.

resist: A resist is used to protect or shield parts of the glass during processes such as acid etching and polishing.

Reusche enamels: A brand of kiln-fired glass paints, used especially in traditional glass painting (stained glass).

rotary grinder: An electric hand tool that works with various grades of discs to grind and polish glass.

router: A machine that can cut and surface-abrade different materials using a rotating/speeding drill head.

screen-printing: The drawing of paint/enamels or fine powders/frits through various-sized mesh screens to transpose an image on to a surface. The screen has an image exposed on to its surface, and with the use of a squeegee, the paint or powder can be forced through to create an image that is fired in a kiln.

sintering: A method of making a form, typically metal or ceramic, from powders, often using miniscule particles held with a mould or former and heated, diffusing the particles into one form.

static head: Stationary cutting head on a machine, which stays vertical and does not rotate or ti.

stencils: A resist used in sandblasting. Also used to mask areas for painting, gilding and other processes that can be applied to glass.

slumping: The melting of glass to enable it to distort over or into a mould or former.

taper: The angle of the cut edge of glass.

Taurus saw: A brand of diamond saw used for cutting glass.

TIFF: A high-resolution graphic file made up of pixels.

tolerances: Tight measurements and weight criteria that have to be met within many glass industries, such as optics.

tool path: The path the tool-head or cutting head will follow whilst milling or cutting.

Tridimension: A phone app for the manufacture of STL files.

Wizard: A brand of machine that grinds glass using water and a small rotating diamond-head. Used to smooth the edges of glass.

UV inks: Coloured inks which are cured (set) by using ultraviolet light.

Vitraglyphic: A term coined by Professor Mark Ganter to explain his method of three-dimensional printing with glass powder.

Index